People

TELEVISION
SHOWS
THAT CHANGED
OUR LIVES

What We Watch

Where were you on the evening of Feb. 28, 1983? If you're old enough, and like 106 million other Americans, you were watching the last episode of *M*A*S*H*.

Jan. 23, 1977? Perhaps, like 28 million households, catching the first installment of *Roots*.

May 6, 2004? The final *Friends*.

June 17, 1994? O.J.'s slow-motion White Bronco chase.

July 18, 1976? Nadia Comaneci's perfect 10.

Through television, tens of millions of Americans have seen some or all of the above; no other activity brings so many people together to share the same experience at the same time. Americans own more than 275 million TV sets and watch some four hours a day. What are they watching?

PEOPLE: *Television Shows That Changed Our Lives* looks at favorites from the past 40 years, from Crowd Pleasers (*Friends, Mary Tyler Moore*) and Cult Classics (*Star Trek, Freaks and Geeks*) to Guilty Pleasures (*Melrose Place*), great moments (*Roots*) and current hits (*Glee*).

For a full tour of the tube, turn the page . . .

Contents

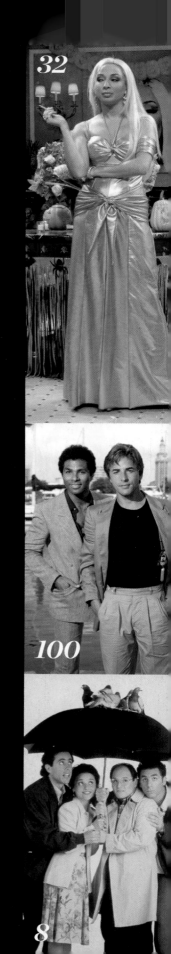

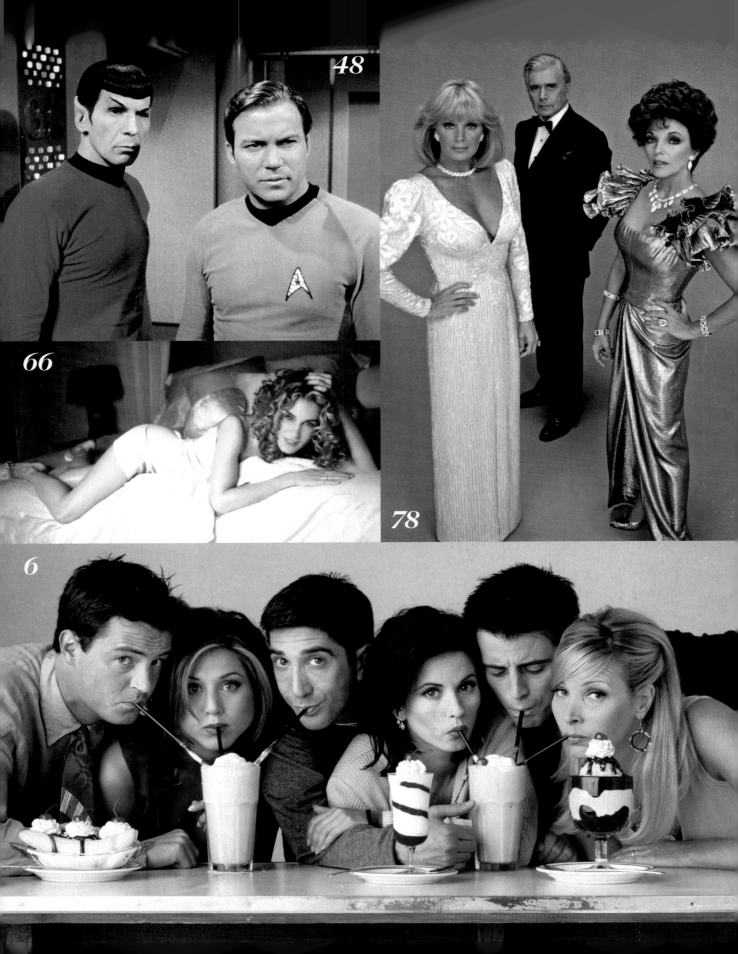

48

66

78

6

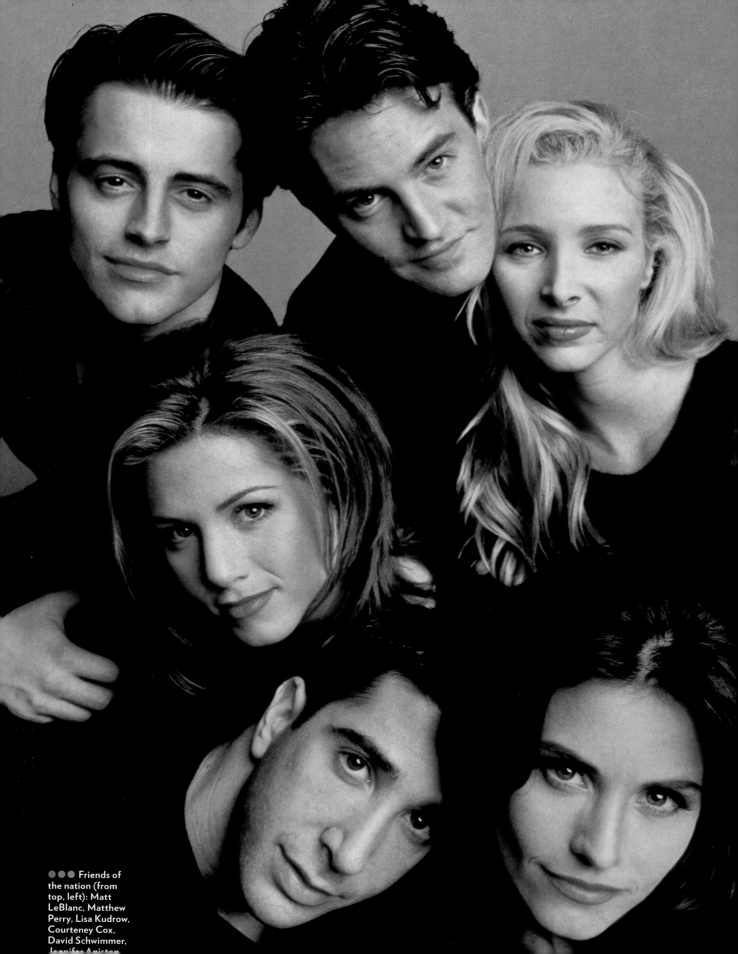

●●● Friends of
the nation (from
top, left): Matt
LeBlanc, Matthew
Perry, Lisa Kudrow,
Courteney Cox,
David Schwimmer,
Jennifer Aniston

CROWD PLEASERS

If you could bottle it, you'd be famous and rich: the ineffable something, or combination of somethings, that add up to a hit TV show. How is **Friends** like **American Idol**? **The Cosby Show** like **M*A*S*H**? Where does **Dallas** intersect with **Mary Tyler Moore**? Sharp writing and an appealing cast explain much but not all. And the setting can be anywhere: a bar, a battlefield, Jerry's **Seinfeld** apartment. The only thing they all have in common: They made America *watch*.

Friends

YOU WANTED THEIR LIVES; YOU SETTLED—LIKE 20 MILLION VIEWERS—FOR WEEKLY VISITS

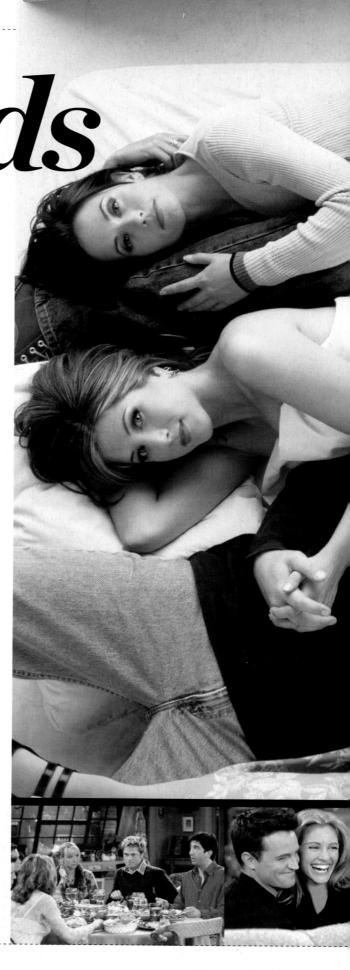

Okay, maybe—just maybe—they weren't really your friends. (It's been six years. Take a breath. *Accept it.*) But they were what you wanted your friends to be: quick-witted (Chandler, Monica); quirky fun (Phoebe); a lovable loser (Ross); a hunk with a heart and a line (Joey, "How *you* doin'?"); and TV's all-time guys-wanna-date-her, girls-wanna-hang-with-her, perfectly coiffed, ab-toned, girl-next-door, charisma-packing babe (Rachel). And if they lived in a fantasy New York where twentysomethings have affordable apartments and nothing bad ever happened that could not be countered with a quip—well, that was pretty much the point. Reality was in the morning paper; relief was on Thursday night at 8 o'clock.

There was a lot more to it than wisecracks, too, though the friends certainly didn't skimp in that department (Rachel, in a PG moment: "And hey! Just so you know. It's not that common, it doesn't 'happen to every guy,' and it is a big deal!" Or Chandler: "I can handle it—handle is my middle name. Actually, it's the middle part of my first name.") Over time viewers became invested in the characters and their postcollegiate struggle—laugh-tracked though it was—to find a place in the world. "*Friends* is about that time in your life when your friends are your family," said co-creator David Crane. "There's a lot of heart in that idea."

After 10 years and 236 episodes—and with the actors all long past college—*Friends* came to a series of happy endings in its May 6, 2004, finale. Even Brad Pitt, then married to Jennifer Aniston (Rachel), got a little emotional. "It was moving, very moving," he said during an appearance on *Conan O'Brien.* "I love that Joey."

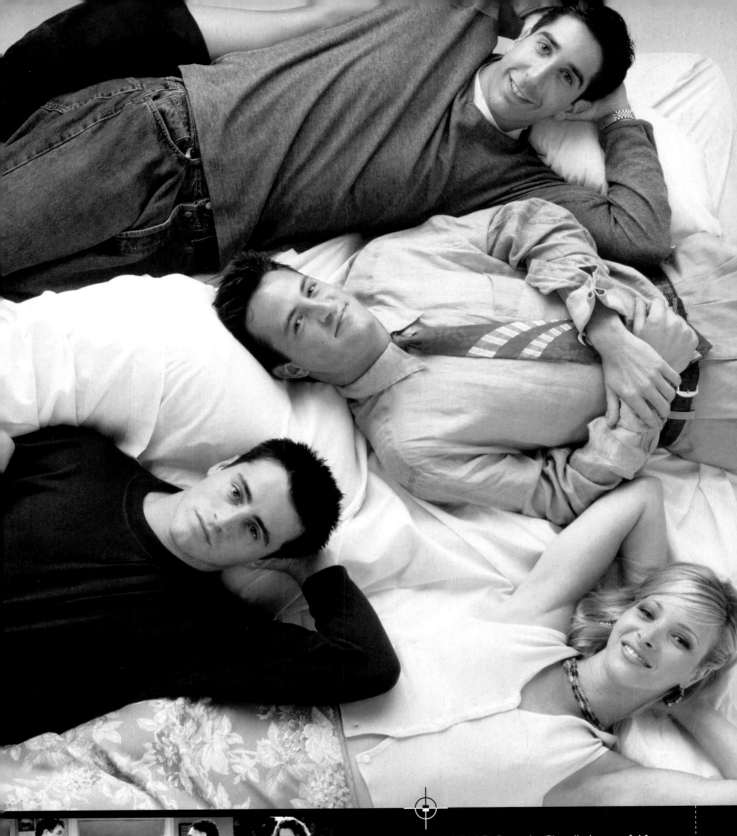

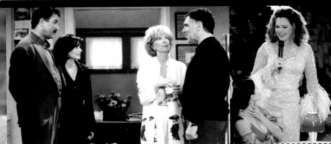

Seinfeld

SECRETLY, A 'SHOW ABOUT NOTHING' LOVED WORDS —NOT THAT THERE'S ANYTHING WRONG WITH THAT

Arguably the best and most revolutionary sitcom of all time, *Seinfeld* initially so underwhelmed NBC executives that in 1990 they gave it only a four-episode commitment— and those episodes aired only because some guy in specials was willing to kill two hour-long shows. Even then, *Seinfeld* was no overnight smash: That didn't happen until *Cheers* ended in 1993 and a prime Thursday slot opened up. The rest, as they say, is catchphrase history: "sponge-worthy," "master of his own domain," "shrinkage," "yada yada yada," "no soup for you." The show, created by its star, comedian Jerry Seinfeld, and his buddy Larry David, set a new tone for TV comedy, celebrating the infantile, morally unconcerned lives of single New Yorkers. It also changed the look

and pacing of sitcoms, using multiple sets, a cardsharp-fast shuffling of intertwined farcical plots and a huge guest cast. "We were making little half-hour movies," Seinfeld later said. By the time he was ready to call it quits, NBC was willing to offer enormous amounts to stretch *Seinfeld* out for a 10th season. Instead the show ended at 9, with a controversial finale that saw its characters—Jerry, Elaine, Kramer and George—locked up in jail. While Larry David went on to give the *Seinfeld* format an even more radical twist with his documentary-style *Curb Your Enthusiasm,* Jerry dialed back his career pace: He married, had kids and studiously steered clear of creating a new sitcom for himself. He told Oprah Winfrey he was happy enough just watching *Sesame Street*: "I sit there and I watch this Elmo guy. And he is so likable and so funny and so charming, and I sit there with my daughter and I think, 'Let him bust his little red ass every week.'"

JERRY'S GIRLS

Seinfeld dated some 62 women, but something—man hands, rampant Schmoopiness—always got in the way. Many moved on—spectacularly.

Teri Hatcher
Jerry suspects she has implants. Her exit line? "They're real—and they're spectacular!"

Kristin Davis
Germophobe Jerry drops her toothbrush in the toilet—then can't bear to kiss her.

Jane Leeves
Things fall apart when Marla—a.k.a. the Virgin—finds out about the master-of-your-domain contest.

Janeane Garofalo
Passionate for Superman, cereal and one-liners, she was too much like Jerry.

Lauren Graham
Made Jerry No. 1 on her speed dial, angering her jealous stepmom, the former No. 1.

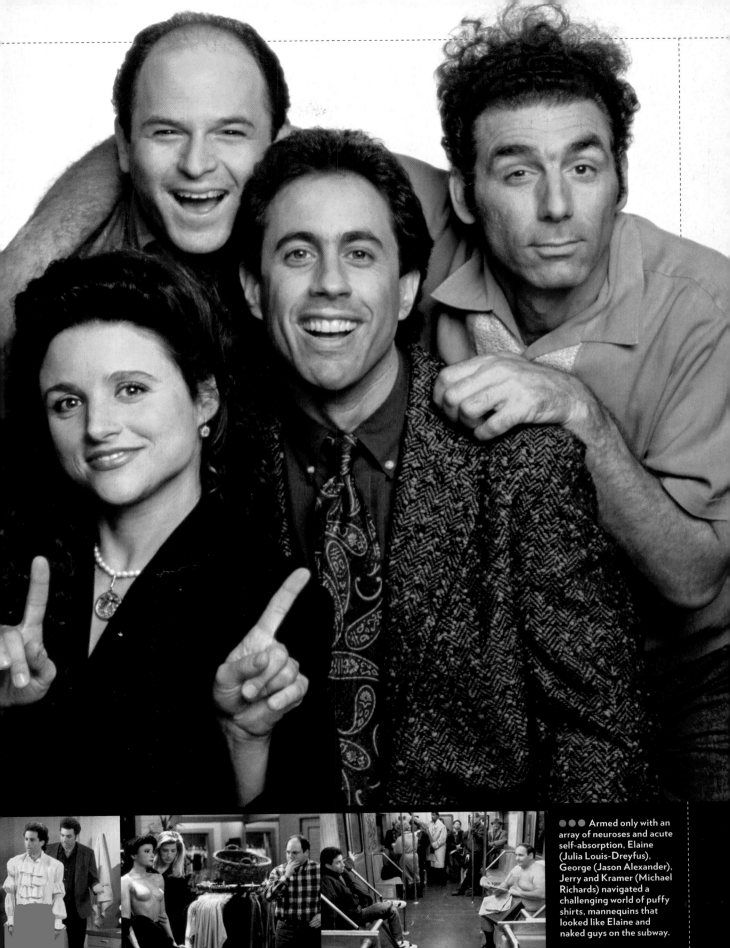

●●● Armed only with an array of neuroses and acute self-absorption, Elaine (Julia Louis-Dreyfus), George (Jason Alexander), Jerry and Kramer (Michael Richards) navigated a challenging world of puffy shirts, mannequins that looked like Elaine and naked guys on the subway.

Mary Tyler Moore

THE SITCOM THAT LET THE GIRL NEXT DOOR GROW UP INTO A SINGLE CAREER WOMAN

Mary Richards was a '70s feminist, a champion of a woman's right to have her own career (at a TV news station in Minneapolis) and space—an apartment where a date could spend the night. In a more freewheeling age, she evolved into Carrie Bradshaw in *Sex and the City.* But Mary Tyler Moore was too fine (and clever) a comedian to play the part as anything but a self-effacing charmer. "She made little squeaks and noises," said the actress. Everything else was laughter.

CBS's *Mary Tyler Moore Show,* which ran from 1970 to 1977 and won 29 Emmys, is still considered a standard-bearer of the American sitcom: smart but never arch; populated by characters who were often eccentric but always humane. Moore produced the show with her then-husband, Grant Tinker, who said of her, "The extraordinary thing about Mary is that she is so extraordinarily normal." In the opening credits, she signaled her freedom with an ordinary, even clichéd gesture, tossing her cap in the air. The image froze, and the cap never came back down.

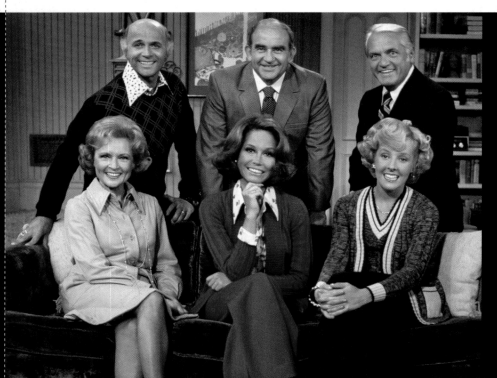

THE DREAM TEAM

Mary Tyler Moore called them "the best cast ever," and they possibly were (clockwise from top left: Gavin MacLeod, Ed Asner, Ted Knight, Georgia Engel, Moore and Betty White; not pictured: Valerie Harper, who played Mary's best pal, Rhoda). The series was a high point for just about all of them. Asner later recalled that "I got the greatest laugh of my life" when he told Mary she had spunk. As she warmed to the compliment, he spat out, "I hate spunk!"

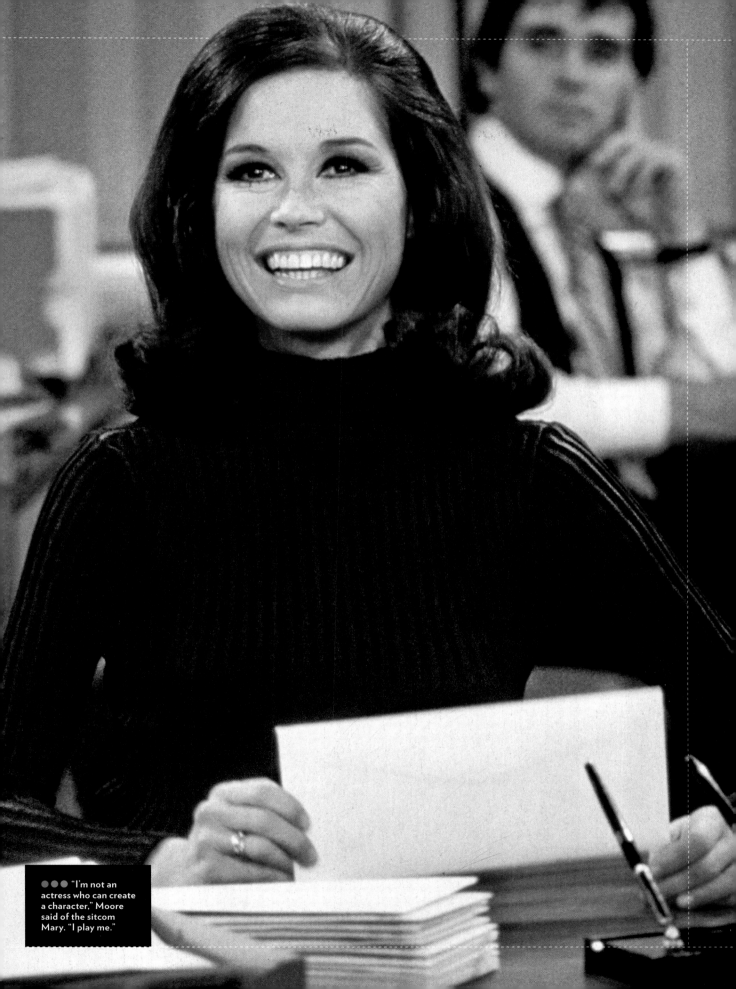

●●● "I'm not an actress who can create a character," Moore said of the sitcom Mary. "I play me."

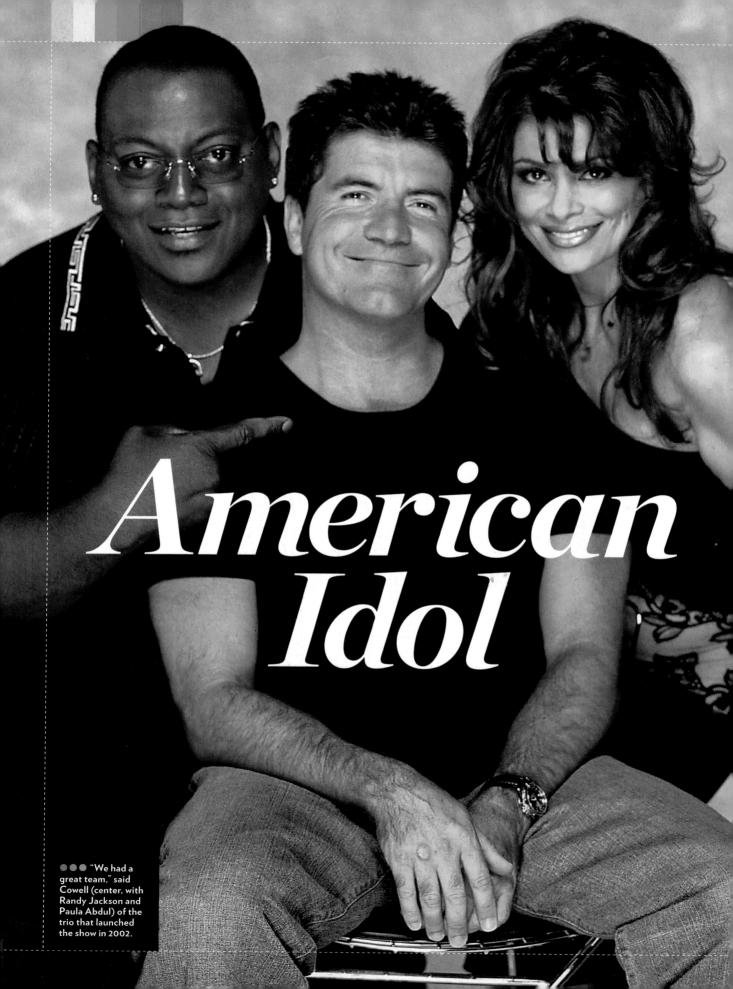

American Idol

IF THE SHOW COULD BE DESCRIBED AS A SINGER, IT WAS A BELTER— AND NO OTHER REALITY SHOW KNEW HOW TO MATCH THE TUNE

American Idol judge Simon Cowell once told *The New York Times* he didn't think the FOX singing contest—the most powerful network program of the new century—was culturally important, or deserved to be. But he felt at least it served as a moral lesson for viewers. "People might be able to get a reality check," he said. "It's not quite as easy to be famous as you think it is."

On this point Cowell, an otherwise canny British music entrepreneur, was dead wrong: No other show ever managed to so catch up viewers (and participants) in the frenzied faith that you can go from nobody to somebody—garage band to Gaga—in one simple step. Adapted from a U.K. hit called *Pop Idol,* the show was a smash soon after its 2002 premiere. Within a few seasons it was being watched by 30 million and generating so much money executives regarded it with a reverence usually reserved for the Super Bowl. It earned almost $900 million in ad revenue in 2008.

And if the singing itself wasn't perfect, so what? A good pop performance, said Cowell, was "like drinking a Häagen-Dazs strawberry milkshake. Just delicious. Why do I like strawberry and not banana? I don't know." *Idol* gave everyone a straw, and America, collectively, slurped.

Only a couple of winners, perhaps, can be said to have achieved the stardom of the show's permanent faces, host Ryan Seacrest and the judges: record producer Randy Jackson; dancer-singer Paula Abdul (replaced in season 9 by Ellen DeGeneres); songwriter-producer Kara DioGuardi and the fiercely blunt Cowell—the man who was not only the show's face but arguably its soul. Cowell's decision to leave in 2010 produced speculation that *Idol,* which had already begun to subside slightly in the ratings, was about to tilt into permanent decline.

Maybe not. As Cowell told *The Times* back in 2004, "With a bit of luck and a bit of skill or whatever, this show could last for another 20 years."

BIGGEST LOSERS

Some *Idol* champs—Carrie Underwood, Kelly Clarkson—made it big, but the truth is you don't have to win to win. Some runners-up and also-rans you may have heard of:

Clay Aiken (season 2): Told by Simon. "You don't look like a pop star," *Idol*'s most successful runner-up has sold more than 4.8 million CDs, thanks largely to his hopelessly devoted fans, the "Claymates."

Jennifer Hudson (season 3): Turned her 7th-place finish into a role in the 2006 movie musical *Dreamgirls* and won an Oscar for Best Supporting Actress.

Chris Daughtry (season 5): After the 4th-place finisher was ejected, he was offered a job with rock band Fuel. He declined but formed his own self-titled band. Their two albums have sold 5.7 million.

William Hung: He heroically butchered Ricky Martin's "She Bangs" during the season 3 audition round. His CD of equally painful cover songs, called *Inspiration*, broke into the Billboard Top 40.

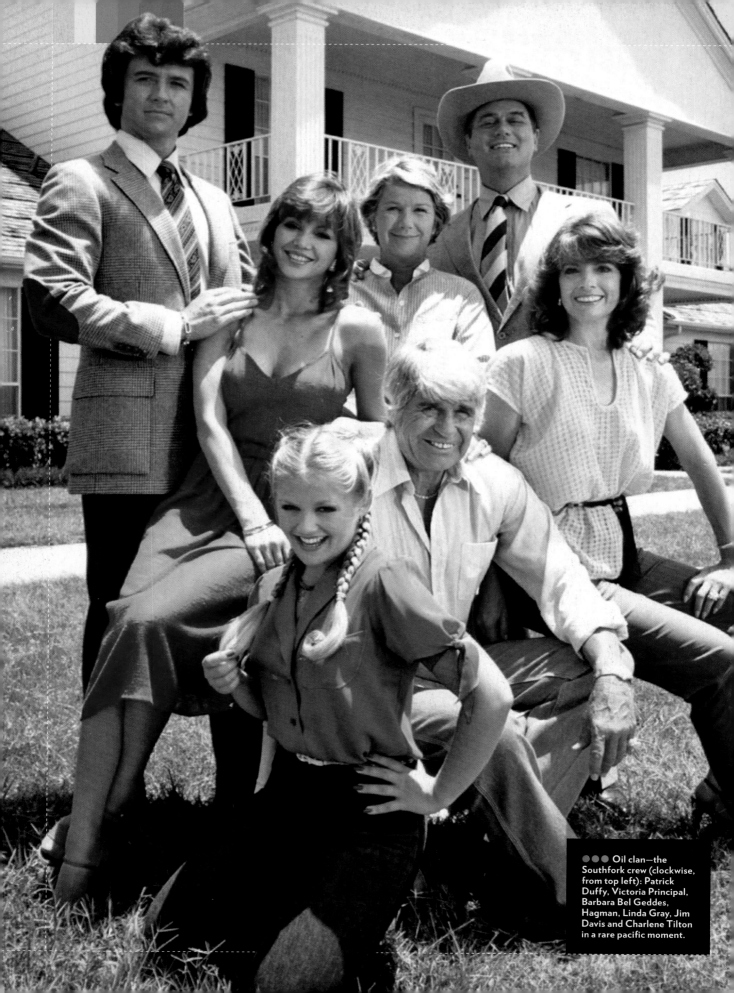

●●● Oil clan—the Southfork crew (clockwise, from top left): Patrick Duffy, Victoria Principal, Barbara Bel Geddes, Hagman, Linda Gray, Jim Davis and Charlene Tilton in a rare pacific moment.

Dallas

HAGMAN & CO. OFFERED LYING, BACKSTABBING AND ADULTERY. THE WORLD SAID, 'MORE, PLEASE!'

'I SHOT J.R.!'

"The thing that was so brilliant is that *everybody* got to shoot Larry," Mary Crosby (a.k.a. Kristin Shepard), now 50, says of the measures taken to keep the plot twist under wraps. "The makeup artist, the grip supervisors . . . everybody was filmed shooting Larry." Later, she says, reaction was overwhelmingly positive. "My favorite response was this beautiful, apple-cheeked lady who was like everybody's fantasy grandmother, who came up to me and said, 'You should have shot him lower.'"

●●● Crosby then and now

A smiling snake in a ten-gallon Stetson, J.R. Ewing once summed up his life philosophy in a crisp 13 words: "Once you get rid of integrity, the rest is a piece of cake."

Audiences ate it up. An unprecedented global hit, the saga of a conniving Texas oilman with a robust love of the seven deadlies—lust and greed seemed particular favorites—was America's No. 1 show for three of its 13 years and eventually aired in over 90 countries. Forty million Americans tuned in on March 21, 1980, for the cliffhanger "Who Shot J.R.?" episode; in Turkey, parliament shut down early so legislators wouldn't miss a moment. And, of course, there had to be some meta-meaning to it all. "I wouldn't be surprised if *Dallas* was planned by a circle of leftist intellectuals in Hollywood as a socialist slander campaign," warned a Danish politician. "The series reinforces the idea that capitalists behave as dirty dogs." At an arts conference in Paris, the French cultural minister indicted J.R. & company as a sinister example of "American cultural imperialism."

As played, gleefully and perfectly, by Larry Hagman, J.R. was pure Texas crude. When a widow complained that he'd driven her husband, a business rival, to suicide, J.R. purred, "I didn't ask you here to nitpick." Before the show wrapped its 356-episode run, he'd bedded some 29 women, married three times (twice to the same woman) and been shot four times. But at its height, *Dallas* itself was bulletproof: At the end of season 9, J.R.'s brother Bobby, dead and buried a year earlier, returned alive, because . . . the entire previous season had been a dream! Audiences howled, but the juggernaut rolled on.

J.R. was larger than life, but Hagman always said the character had real roots. "I grew up in Texas, so I know those old boys . . . and how they operate," he said. "Actually, I did base J.R. on one guy I knew. But I'll never tell his name. It wouldn't be fair to him. And he carries a gun."

M*A*S*H

MIXING DEFT SURGEONS AND SMOOTH OPERATORS, A DARING COMEDY CUT TO THE QUICK

Sure, you've got your *Friends* and *Seinfeld*, your *Cheers* and even your *Doogie Howser, M.D.* But know this: Only one show in TV history can claim the most-watched finale (106 million viewers, on Feb. 28, 1983)—and that show is *M*A*S*H*.

Based on the gallows-humor film of the same name, the TV show, set during the Korean War, dared to mix comedy (wisecracking surgeons, a cross-dressing clerk) with poignant, and sometimes painful, moments. That balance, and sharp writing, gave *M*A*S*H* its unique identity. "I wanted to make sure we weren't making an *Abbott & Costello Go to Korea*," said star Alan Alda, who also wrote and directed many episodes. "The war had to be a springboard for our best efforts, exploring the horror, not ignoring it." Canned laughter, the mother's milk of sitcoms, was banned during operating-room scenes, and a warm moment might be shattered by a jolt of reality—as it was when Lt. Col. Henry Blake, a beloved character, died suddenly when his plane was shot down.

Other shows have stumbled after similar departures. *M*A*S*H* created new characters—Mike Farrell's B.J. Hunnicutt, Harry Morgan's Sherman Potter—and soldiered on. And on. When it ended, *M*A*S*H* had run for 11 years—eight more then the Korean War.

FARR OUT

Among the show's colorful characters, no one stood out more than Corporal Klinger (Jamie Farr), who flitted about in skirts, hoping for a psychiatric discharge. "Loretta [Swit] hated me because I had better clothes than she did on the show," says Farr. Some ensembles were prop clothing previously worn by screen sirens like Betty Grable and Ginger Rogers, who once told him, "I saw you with my outfit on the other night. You know, it sure looked a heck of a lot better on you than it did on me." Compliments aside, Farr, 76, who still performs regularly in regional theater, says his drag days are over: "I often tell people that they don't have enough money to get me into a dress, and they don't have enough to get me out of a dress." But the memories linger. "*M*A*S*H* was the best time of my life," he says. "I got paid for having fun."

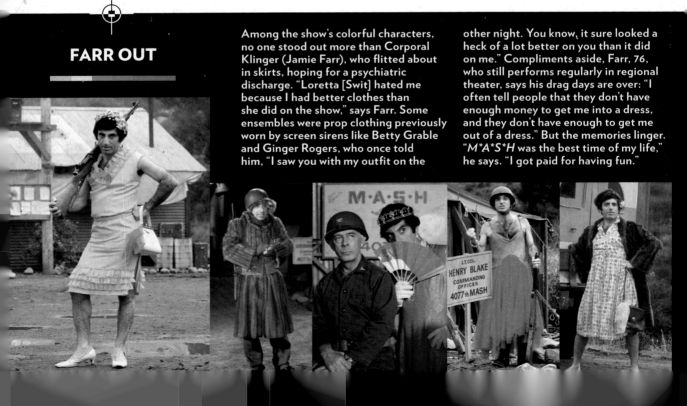

●●● The 4077th Mobile Army Surgical Hospital unit (back row, from left): David Ogden Stiers and William Christopher; (middle row): Mike Farrell, Alan Alda, Loretta Swit and Harry Morgan; (seated): Jamie Farr.

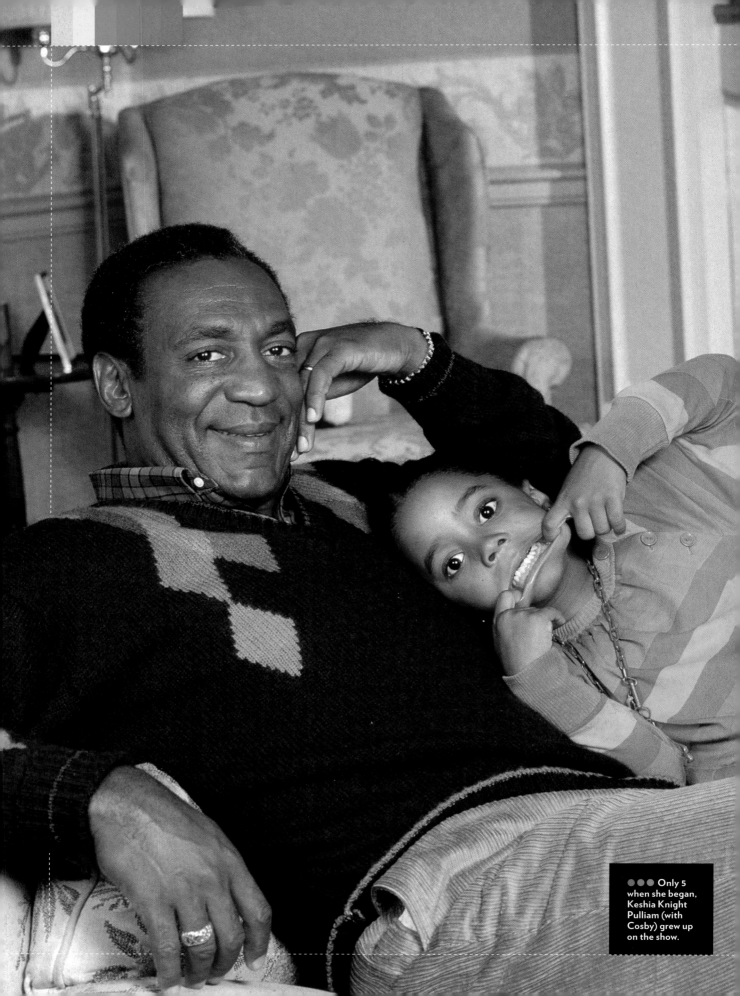

●●● Only 5 when she began, Keshia Knight Pulliam (with Cosby) grew up on the show.

The Cosby Show

It might have worked, but it probably wouldn't have been memorable: When he first discussed doing a sitcom, Bill Cosby wanted to play a limo driver married to a plumber. His producer, Marcy Carsey, suggested he play a doctor instead. Cosby took the idea and made TV history.

"The brilliant thing *Cosby* did was to put race and economic issues on the back burner," said Henry Louis Gates Jr., then the chairman of Harvard's African-American studies department. "[It was] a black family dealing with all the things black people deal with the same as all other people." In watching the lighthearted travails of Dr. and Mrs. Huxtable and their four kids, millions of Americans of all races saw themselves (or, perhaps, who they hoped to be): *Cosby* was No. 1 for four of its eight seasons. Which isn't to say that *Cosby*'s resolutely bourgeois sensibility always suited the African-American community: Some complained that the family had it too easy and rarely mentioned the ugly toll of racism. "I don't know how to do that without getting angry," Cosby explained. "That's not funny to me."

Instead, Cosby focused on the joys in life, reveling in the universality of family hijinks and underscoring the achievements of African-American artists—and, always, the importance of education. Later, Cosby's own family life would be touched by scandal and, worse, the random murder of his son Ennis, whose antics were the inspiration for Cosby's TV son Theo. But his contributions to society, from his single-handed revitalizing of NBC to his impact on African-American colleges and race relations, were, and remain, set in stone.

CATCHING UP

A look at where the celebrated series' smallest stars (and their TV Dad's famous duds) are now.

Little Rudy no longer, Keshia Knight Pulliam, 31, is a Spelman College grad and actress on TBS's *Tyler Perry's House of Payne.*

Once the pint-size scene-stealer Olivia, Raven-Symoné, 24, is now a multimillionaire thanks to her Disney show *That's So Raven* and a successful recording career.

Whither Bill's sweaters? The Cos's signature threads were auctioned off for charity on eBay in 2008.

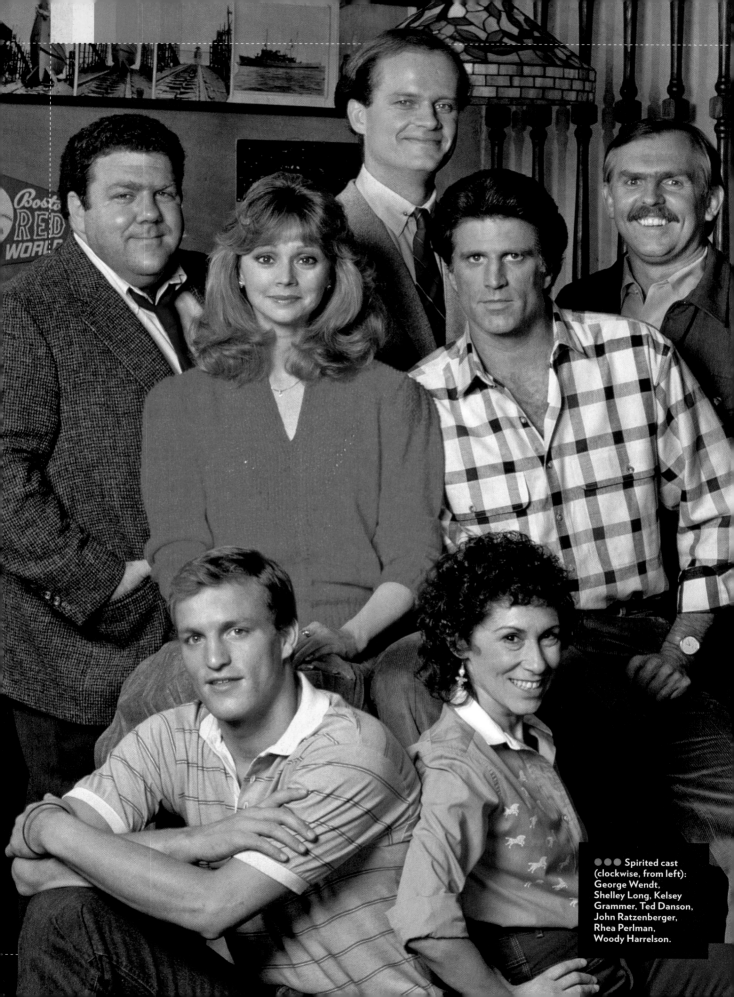

● ● ● Spirited cast
(clockwise, from left):
George Wendt,
Shelley Long, Kelsey
Grammer, Ted Danson,
John Ratzenberger,
Rhea Perlman,
Woody Harrelson.

Cheers

IT WAS THE PLACE WHERE EVERYONE KNEW YOUR NAME—AND WHERE AMERICA WENT FOR LAUGHS FOR 11 YEARS

You could say that in a fictional Boston bar called Cheers, great characters, brilliant zingers and memorable moments were the "*Norrrrmmmm!!!*" An amazingly consistent comic sensibility kept fans of NBC's *Cheers* bellying up for laughs for more than a decade, quite a run for a show set mostly around a beer tap. Quick on its feet but not madcap, full of sentiment but not sentimental, *Cheers* charmed its way to 28 Emmys from 1982 to 1993—including four for Best Comedy Series; a record broken only by its witty spinoff *Frasier.*

Quality scripts gave life to a quirky bunch of regulars—skirt-chasing jock-turned-barkeep Sam Malone, whose romance with haughty waitress Diane set the standard for stop-and-go TV couplings; Coach and Woody, the dimwit mixologists; live-with-his-mom mailman Cliff Clavin; and chubby accountant Norm, king of the self-deprecating wisecrack ("What's shaking, Norm?" "All four cheeks and a couple of chins"). Sure, some of the jokes were silly, but they were never cheap—the series refused to stray from its simple formula, durable as Norm's bar stool. "For 11 years we did a show about a guy who chases women and his friends who sit around drinking beer all day," said co-executive producer Rob Long. To that gang, a toast: "Cheers."

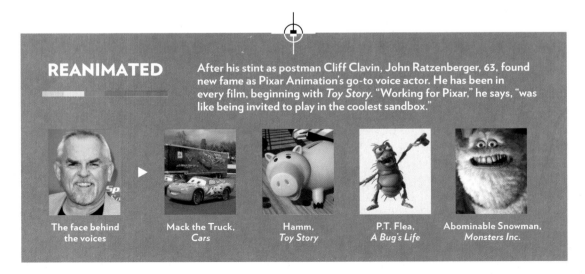

REANIMATED

After his stint as postman Cliff Clavin, John Ratzenberger, 63, found new fame as Pixar Animation's go-to voice actor. He has been in every film, beginning with *Toy Story.* "Working for Pixar," he says, "was like being invited to play in the coolest sandbox."

The face behind the voices

Mack the Truck, *Cars*

Hamm, *Toy Story*

P.T. Flea, *A Bug's Life*

Abominable Snowman, *Monsters Inc.*

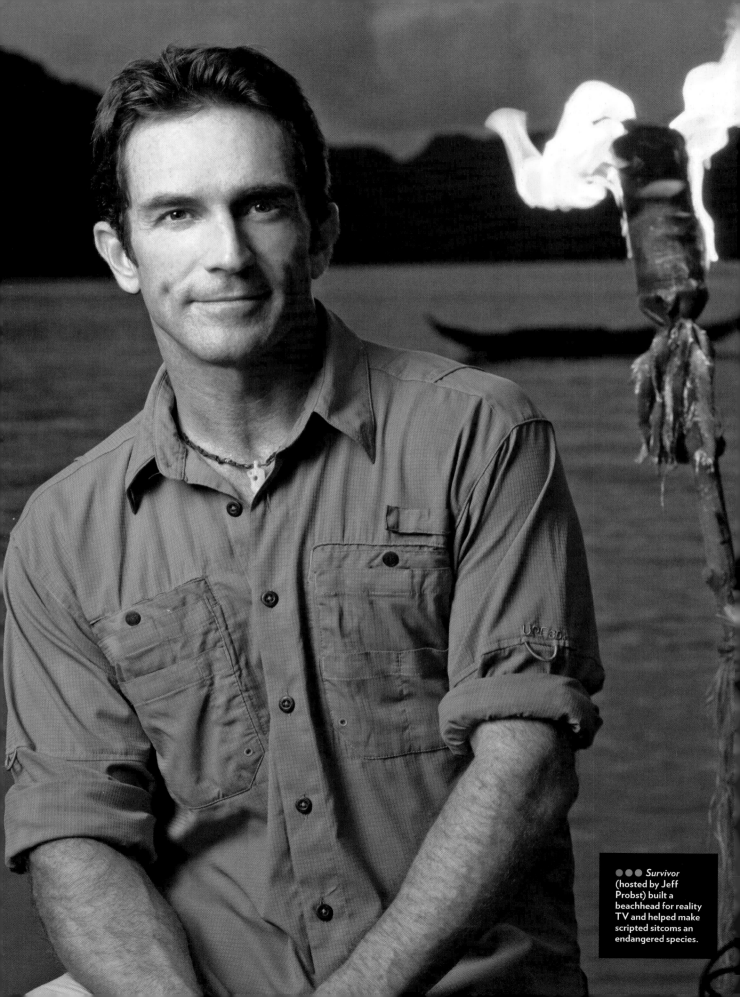

GAME CHANGERS

Hawaii Five-O, CHiPs, Starsky and Hutch, and then . . . **Hill Street Blues. The Smothers Brothers Comedy Hour, The Carol Burnett Show** and . . . **Saturday Night Live. The Adventures of Ozzie and Harriet, The Brady Bunch** and . . . **All in the Family. Yogi Bear, The Flintstones** and . . . **The Simpsons.** For every genre—cop show, sketch series, sitcom, cartoon—there is, every once in a while, a revolution. It's natural. It's predictable. And, very often in the past 40 years, it happened when the generation that grew up *watching* TV suddenly got the chance to *make* TV. And someday, of course, the same thing will happen to them.

All in the Family

A BLUSTERING BLUE-COLLAR BIGOT, ARCHIE BUNKER MADE AMERICA LOOK, LAUGH AND THINK

If a couple of thousand years of Judeo-Christian ethic have not solved the problems of bigotry and narrow-mindedness," writer-producer Norman Lear once said, "I'd be a fool to think a little half-hour situation comedy is gonna do the trick."

Still: worth a try! As the creator of *All in the Family* and its spinoffs *Maude* and *The Jeffersons,* Lear combined the loftiness of a progressive Victorian thinker with a killer instinct for situation comedy. *Family,* which premiered in 1971, was about Archie Bunker (Carroll O'Connor), a working-class Queens man who liked President Nixon, picked on his "dingbat" wife, Edith (Jean Stapleton), called his hippie son-in-law Meathead and didn't see any problem with words like "spic" and "spade." The purpose of allowing a bigot to stand before a camera and say these awful things was explained by a genteel note at the start of the premiere: "[*Family*] seeks to throw a humorous spotlight on our frailties, prejudices and concerns. By making them a source of laughter, we hope to show, in a mature fashion, just how absurd they are."

Whether the show actually educated viewers or gave them unintentional license to talk like Archie has remained a point of debate. (When all is said and done, one of the greatest taboos ever shattered by Lear was a silence: The first time a

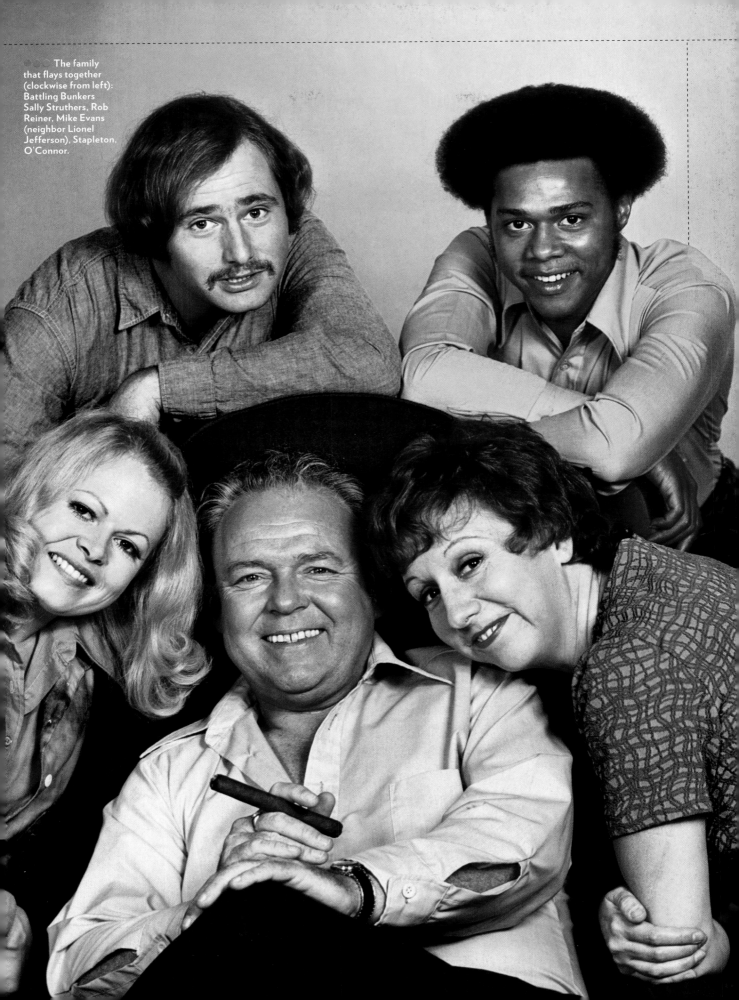

The family that flays together (clockwise from left): Battling Bunkers Sally Struthers, Rob Reiner, Mike Evans (neighbor Lionel Jefferson), Stapleton, O'Connor.

All in the Family

TV audience heard a toilet flush was on *Family.*) But the show became a huge hit and created hit spinoffs. *Maude* (1972), starring Bea Arthur as Edith's domineering liberal cousin, tackled everything from abortion to face-lifts. *The Jeffersons* (1975) were the first upscale black family on prime time.

But what audiences loved wasn't so much Lear's politics or willingness to introduce hot-button topics like the pill, homosexuality or even swingers. It was his talent for finding great comic actors who brought their characters to vivid life (one of those swingers was played by a then-unknown Rue McClanahan). No one ever forgot Archie shouting, "Edith! Stifle yourself!"

O'Connor, who won four Emmys in the role, also brought out something unexpectedly touching in Archie. "Archie's dilemma is coping with a world that is changing in front of him," O'Connor said. "He isn't a totally evil man. . . . But he won't get to the problem because the root of the problem is himself, and he doesn't know it."

Family, which was based on a British sitcom, lasted for nine seasons. O'Connor continued to play Archie in a softer spinoff, *Archie Bunker's Place,* for another four years. (Edith was revealed to have died of a stroke at the start of its second season.) It remains a footnote to *All in the Family,* which changed the face of TV. For a while, anyway. "The show was more of an oasis than something revolutionary," Rob Reiner later said. "When it went off the air, all the garbage came back on."

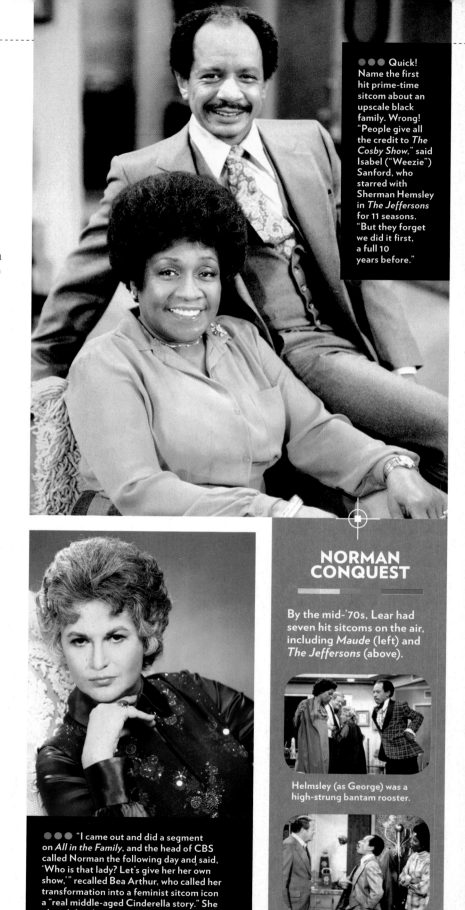

● ● ● Quick! Name the first hit prime-time sitcom about an upscale black family. Wrong! "People give all the credit to *The Cosby Show,*" said Isabel ("Weezie") Sanford, who starred with Sherman Hemsley in *The Jeffersons* for 11 seasons. "But they forget we did it first, a full 10 years before."

NORMAN CONQUEST

By the mid-'70s, Lear had seven hit sitcoms on the air, including *Maude* (left) and *The Jeffersons* (above).

Helmsley (as George) was a high-strung bantam rooster.

● ● ● "I came out and did a segment on *All in the Family,* and the head of CBS called Norman the following day and said, 'Who is that lady? Let's give her her own show,'" recalled Bea Arthur, who called her transformation into a feminist sitcom icon a "real middle-aged Cinderella story." She played the character perfectly—but there was a lot of acting involved. "Actually," she said years later, "I'm not that politically involved."

Lear's diagnosis of *The Jeffersons*: "Funny is funny."

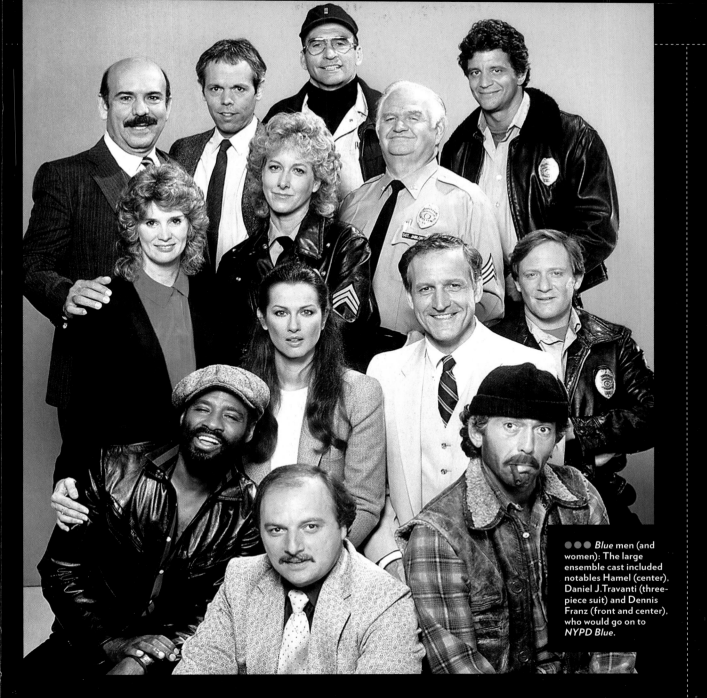

●●● *Blue* men (and women): The large ensemble cast included notables Hamel (center), Daniel J. Travanti (three-piece suit) and Dennis Franz (front and center), who would go on to *NYPD Blue.*

Hill Street Blues

"Let's be careful out there," crusty old Sergeant Esterhaus always told his cops—but the revolutionary police drama *Hill Street Blues* was anything but. Handheld cameras, choppy editing, jarring, surreal violence—all cop show staples now—were stunning innovations in *Hill Street*'s 1981 pilot, about a ragtag gang of lovably flawed crime fighters. Unhinged Detective Belker, who liked biting perps; squad leader Frank Furillo, the recovering drunk; and Veronica Hamel's slinky Joyce Davenport—the prototype knockout public defender—all brought a messy, tender humanity to their chaotic inner-city precinct. Debuting mid-season on last-place NBC (co-creators Steven Bochco and Michael Kozoll were given free rein by nothing-to-lose network execs), *Hill Street* struggled for ratings but racked up a then-record 21 Emmy nods its first year (it won 26 overall in seven seasons). Its legacy: introducing multiple story arcs and movie-level character complexity to prime-time TV. As James B. Sikking, who played hawkish Lieutenant Hunter, put it, "I'd done acres of crap. This was special."

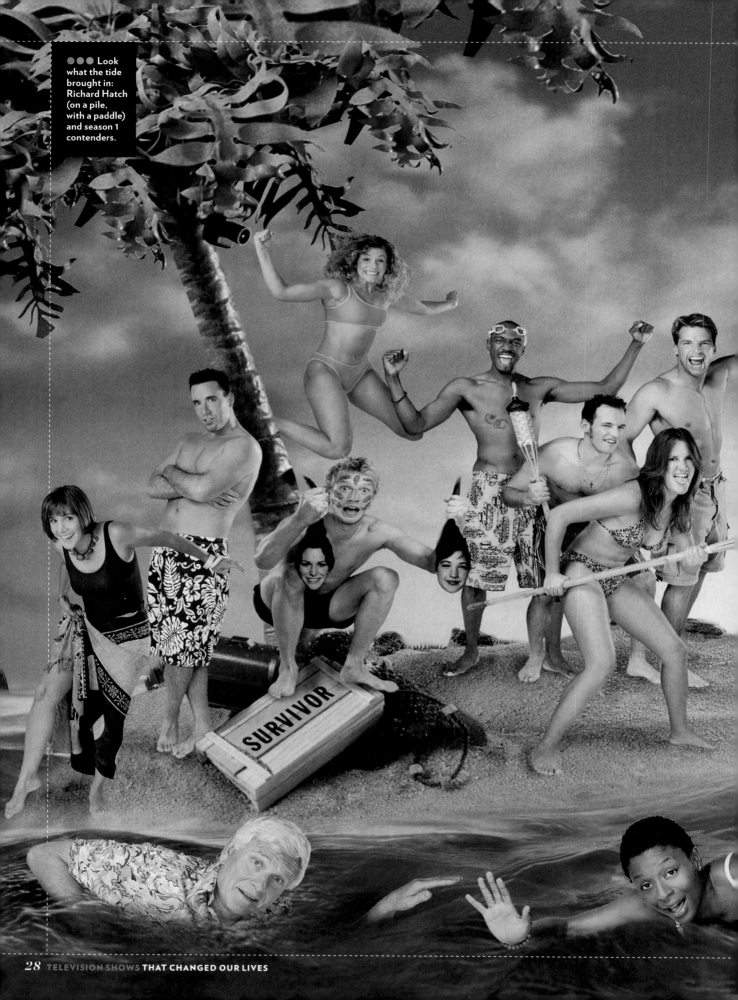

●●● Look what the tide brought in: Richard Hatch (on a pile, with a paddle) and season 1 contenders.

SURVIVOR

Survivor

A SORT OF *LORD OF THE FLIES* WITH A BIG
CASH PRIZE, IT TURNED PRIMAL BEHAVIOR
INTO PRIME-TIME ENTERTAINMENT

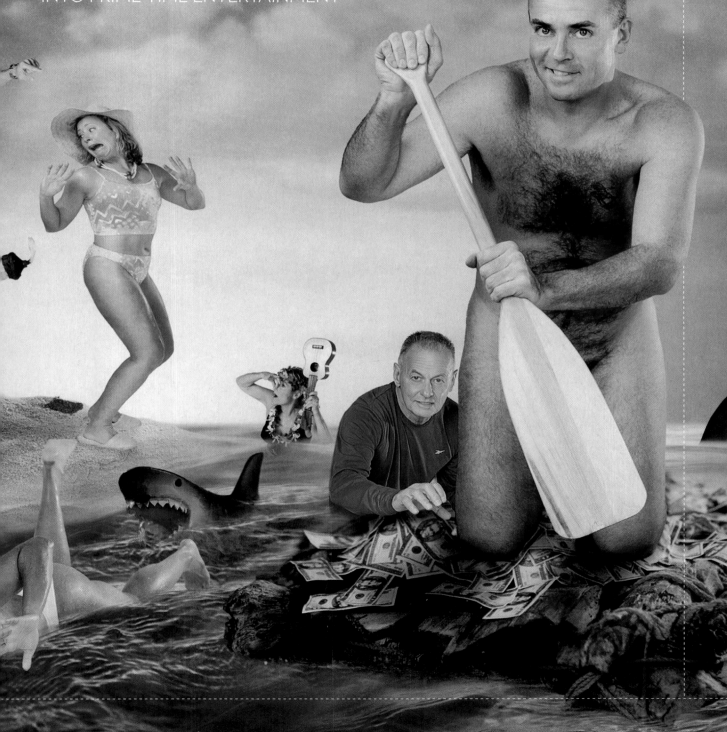

Survivor

The tribe had spoken. And when 51 million viewers tuned in to learn the verdict in August 2000, the show was hailed for resuscitating reality TV, then a struggling new form of entertainment. With viewers feeling burned out by ABC's three-nights-per-week *Who Wants to Be a Millionaire* and burned by FOX's *Who Wants to Marry a Multi-Millionaire*—sunk by scandal when winner Darva Conger was misled into marriage by a groom with a troubling past—*Survivor* was a savior.

Based on *Expedition Robinson*, a Swedish program, *Survivor* was greeted with little notice and zero fanfare. But its Crusoe-meets-Gilligan premise—16 castaways left to fend for themselves and outwit one another on a remote island inhabited by snakes, rats and round-the-clock camera crews—was an instant hit drawing 23 million viewers just three weeks into its run. Quick to emerge from the back-stabbing cast was a universally loathed, utterly riveting character whom traditional Hollywood casting, or wardrobe, departments, would have been hard-pressed to produce. Richard Hatch, a prickly, 39-year-old, openly gay, hairy, non-buff guy who spent much of his camera time naked, proved equally adept at outmaneuvering *and* grossing out the competition. When the smoke from tribal torches cleared, Hatch won the $1 million prize. (He later went to jail for failing to pay income tax on his windfall.)

At heart, series producer Mark Burnett said, *Survivor* was old-fashioned television: "It was simple storytelling, with compelling characters in a setting we could all understand." And sand fleas.

PROBST'S FAB 3

The affable host looks back on his storied tenure and selects the most memorable moments.

1 Jonny Fairplay fakes his grandmother's death for sympathy points (Pearl Islands): "A great moment for *Survivor*. . . . It spun the show in a new direction. He was the first person to ever tell a big lie."

2 Sue Hawk's rats-and-snakes speech (Borneo): "To see this truck driver standing there, lecturing these other people on the way the world works, was just beautiful."

3 Erik Reichenbach gives up his immunity necklace (Fans vs. Favorites): "He had a pair of breasts staring at him that he just couldn't resist. These sexy women talked him into doing something that was very regrettable."

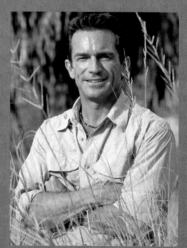

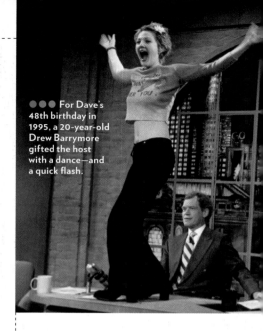

● ● ● For Dave's 48th birthday in 1995, a 20-year-old Drew Barrymore gifted the host with a dance—and a quick flash.

Madonna visited David Letterman's *Late Show* in 1994, and the CBS talk host was not happy with the way it turned out. She provocatively insisted on using a profanity, and more than once. Letterman, on reflection, said he should have thrown her out but didn't have the nerve. He told an interviewer he faulted himself: "You're such a pretender. You're pretending you're *The Tonight Show*—but you never saw [Johnny] Carson break a sweat."

That skeptical bleakness has been key to Letterman's iconic, highly influential comic personality. He's successor not so much to Carson as W.C. Fields (and maybe twin brother to Bill Murray). He was also a lightning rod for inspired, great silliness: As host of NBC's post-Carson *Late Night* in 1982, he introduced the Top 10 List—the only major talk show innovation since the opening monologue. Moving to CBS in 1993 and going up against a Jay Leno–hosted *Tonight* (a job he'd wanted), he gave CBS its first successful rival to the NBC juggernaut. Eventually Letterman got married, had a kid, survived heart surgery, survived a sex scandal and grew more comfortable in his skin. And called Leno "a complete boob" and still seemed somehow to wish he were as cool as Johnny.

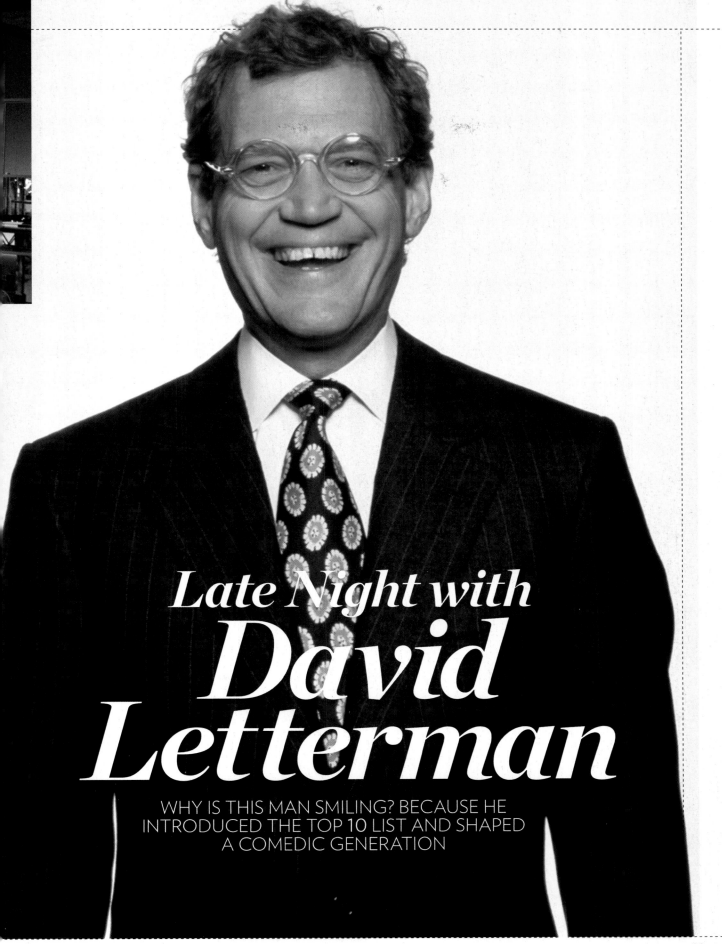

Late Night with *David Letterman*

WHY IS THIS MAN SMILING? BECAUSE HE INTRODUCED THE TOP **10** LIST AND SHAPED A COMEDIC GENERATION

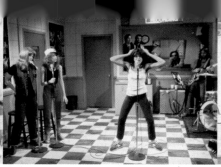

●●● New York City Mayor Ed Koch received a classic Belushi diatribe.

Belushi felt the Bees were a buzz kill.

Gilda Radner sang an ode to Mick Jagger: "You don't keep regular hours."

Eddie Murphy: a Buckwheat moment.

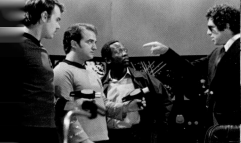
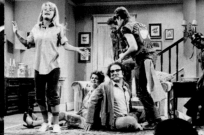
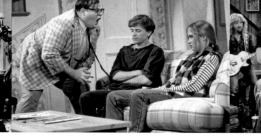

Guest host Elliott Gould played an NBC suit with bad news: *Star Trek* was canceled.

Dyan Cannon sang "Johnny Angel" during a home invasion by a biker gang.

Motivational speaker Chris Farley gave David Spade and Christina Applegate lessons in loud.

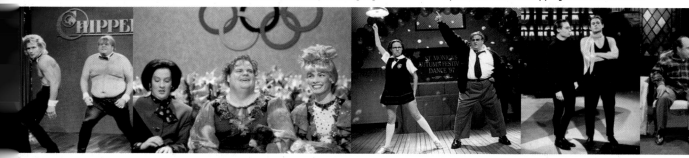

Patrick Swayze and Chris Farley sizzle.

Lillehammer drag: Olympian Nancy Kerrigan joined Farley and Melanie Hutsell (left).

Sympathy dance: Molly Shannon and Farley conjured Travolta.

Rob Lowe joined Myers in "Dieter's Dance Party."

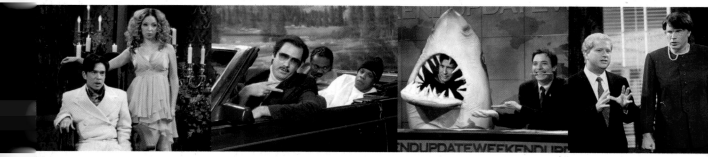

Purple Feign: Prince (Fred Armisen) and Beyoncé (Maya Rudolph).

Yo Riders: Will Ferrell channeled Robert Goulet rapping with Jay-Z.

Land Shark! Chevy Chase reprised a *Jaws*-inspired skit with Jimmy Fallon.

Darrell Hammond's Clinton, Will Ferrell's Reno.

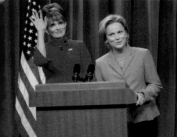
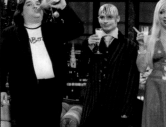

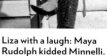

You betcha! Tina Fey (left) and Amy Poehler as Palin and Clinton.

Rosie O'Donnell (Horatio Sanz), Boy George (Elijah Wood) and Donatella Versace (Rudolph).

Hey, Jude: Guest host Law auditioned for *Hamlet* with Bill Hader.

Liza with a laugh: Maya Rudolph kidded Minnelli.

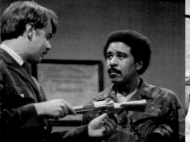

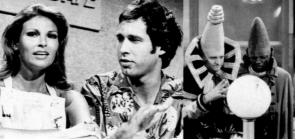

Richard Pryor (with Dan Aykroyd) accidentally swallowed a poison pill.

Chevy Chase (with Raquel Welch) originated "Weekend Update."

Coneheads: laughs in mass quantities.

Radner's Roseanne Roseannadanna (left) to Curtin: "I thought I was gonna die!"

Aerosmith entered *Wayne's World.*

Coffee talk: Mike Myers, Glenn Close got verklempt.

Saturday Night Live

AFTER MORE THAN THREE DECADES OF MOCKING INSTITUTIONS, IT IS ONE

"Land Shark." "We're from France." "Well, isn't that special." "We just want to pump . . . you . . . UP!" "You look mahvelous." "Never mind." "Cheeseburger, cheeseburger."

Bidden or otherwise, many of those phrases, like great pop-music hooks, are probably thriving somewhere in your cranium. Need further proof of *Saturday Night Live*'s influence—that, 35 years in, it's still the Sorbonne-slash–petri dish-slash-perpetual freshman dorm of American Comedy? Among other things, the sheer number of *SNL* graduates—from Dan Aykroyd and John Belushi to Julia Louis-Dreyfus, Martin Short, Ben Stiller, Dennis Miller, Bill Murray, Eddie Murphy, Mike Myers, Will Ferrell and Tina Fey—is impressive (124). Ditto the count of *SNL*-character based movies (11, from *The Blues Brothers* and *Wayne's World* to the inexplicably extant *It's Pat* and *A Night at the Roxbury* and the recent, alarming *MacGruber*).

The tone may have been set before the show even started, when John Belushi, then 26, went for a job interview. "He walked into my office and started to abuse me," producer Lorne Michaels recalled. "He said, 'I can't stand television,' and that was just the kind of abuse I wanted to hear."

In short order the inmates had the keys to the asylum—or, more precisely, a generation that had grown up watching their parents' idea of comedy finally got to tell their own jokes.

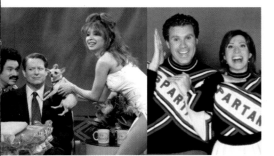

"Isn't that special!" Danny DeVito with Dana Carvey.

Senior drag: Farley and Adam Sandler.

Al Gore went Poco Loco with Armisen and Rudolph.

Will cheer for laughs: Ferrell and Cheri Oteri.

Host Fight: Conan (Hader, right) and Leno (Hammond) fume; King (Armisen) refereed.

A show of hands for Vincent Price (Hader) and Carol Channing (Wiig).

Golden Girl Years: Fans' Facebook campaign paid off with a winning guest turn by Betty White, 88.

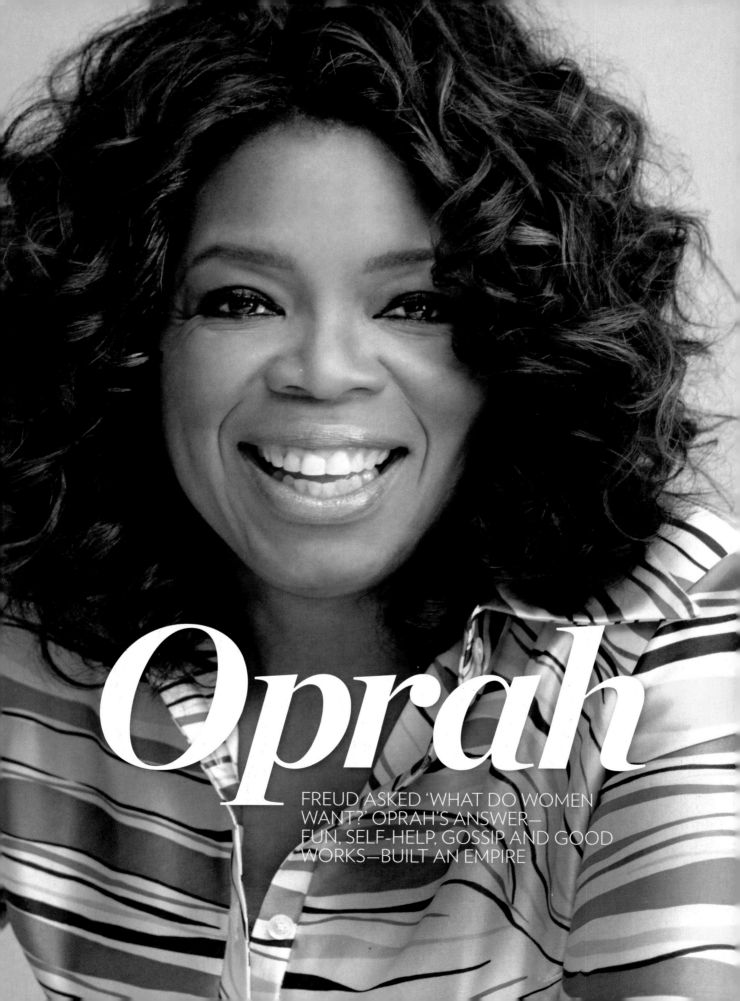

Oprah

FREUD ASKED 'WHAT DO WOMEN WANT?' OPRAH'S ANSWER— FUN, SELF-HELP, GOSSIP AND GOOD WORKS—BUILT AN EMPIRE

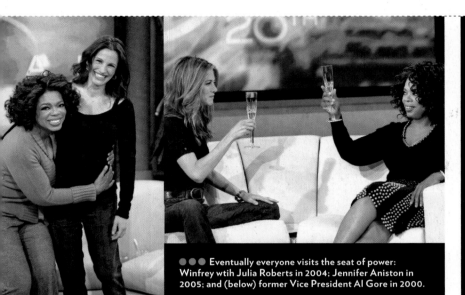

● ● ● Eventually everyone visits the seat of power: Winfrey with Julia Roberts in 2004; Jennifer Aniston in 2005; and (below) former Vice President Al Gore in 2000.

You could say the key to *The Oprah Winfrey Show*'s unbeatable, quarter-century success is that everyone can empathize with its star, but no one can quite figure out what makes her tick. *Oprah,* which began airing from Chicago in 1986, dominated the nation like no other syndicated talk program, generating some of the most iconic (and, same thing, parodied) scenes in TV history: Oprah giving away cars to her shrieking studio audience . . . Oprah showing off her weight loss by hauling 67 lbs. of fat onto the stage in a little red wagon . . . Oprah staring at a love-struck Tom Cruise kangarooing on her furniture . . . Oprah calmly vivisecting author James Frey after she'd endorsed his heavily fabricated memoir. Over the years she became ever more glowingly glamorous while using her flagship show to launch and produce new hits (*The Dr. Oz Show*), influence politics (she backed Obama) and promote good causes. She'll finally end the show in 2011 to take the next logical step: starting her own cable network. What is TV? If you're Oprah, total validation. As she recalled, "One woman came up to me, I'll never forget it, and said, 'Watching you be yourself makes me want to be more myself.'"

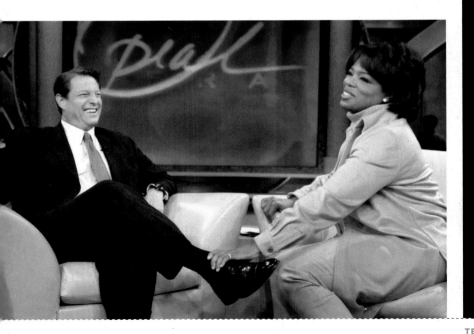

TOUCHED BY AN OPRAH

Thee ways to get rich:
1) Choose wealthy parents.
2) Invent something useful, like the wheel or fire.
3) Earn Oprah's endorsement. Some who have:

DR. PHIL
Hired by Oprah to consult in a legal case, he became a regular guest. Now a bestselling author with his own talk show.

RACHAEL RAY
Chef and frequent guest. Now . . . has her own talk show (coproduced by Harpo Productions).

DR. MEHMET OZ
Heart surgeon and frequent guest. Now . . . has his own talk show.

NATE BERKUS
Oprah's go-to design guru. Now . . . scheduled to have his own talk show.

BOB GREENE
Oprah's personal trainer; best-selling author of 11 books.

WALLY LAMB
Oprah's on-air book club helped make his first two novels, *She's Come Undone* and *I Know This Much Is True*, bestsellers.

CNN

24-HOUR NEWS PROVED DOUBTERS WRONG; SPORTS AND, YES, WEATHER FOLLOWED SUIT

This . . . is CNN. America's first 24/7 cable news network. The world's only source for live video coverage of the United States' nighttime attack on Baghdad in January 1991. The home of spellbinding as-it-happened video from the *Challenger* disaster, O.J. Simpson's slow-mo car chase and the horrors of 9/11.

First imagined in the mid-'70s as a news-centered spinoff for HBO, the all-news cable channel eventually found a home as part of Ted Turner's newly fledged, Atlanta-based cable TV empire. Launched on June 1, 1980, with a potential audience of 2 million viewers, CNN grew quickly, adding global coverage, to its current reach of more than 2 billion viewers in more than 200 countries. What they've been watching is an ever-changing array of live programs running the gamut from hard news to showbiz gossip.

Always a viewer magnet in times of crisis, the world's original cable news channel has a tougher time attracting viewers when things calm down. Particularly when news channels (see also: current ratings champ FOX News) lean heavily on the personality-fueled pyrotechnics of shouting heads like Glenn Beck, Bill O'Reilly and MSNBC's Keith Olbermann. But when it comes to in-the-moment reportage, the world still flocks to the inventor of the form.

Thirty years after CNN's cable news broadcast began, the signal has yet to flicker. Ted Turner promised as much in the channel's first moments.

"We won't be signing off," he declared, "until the world ends."

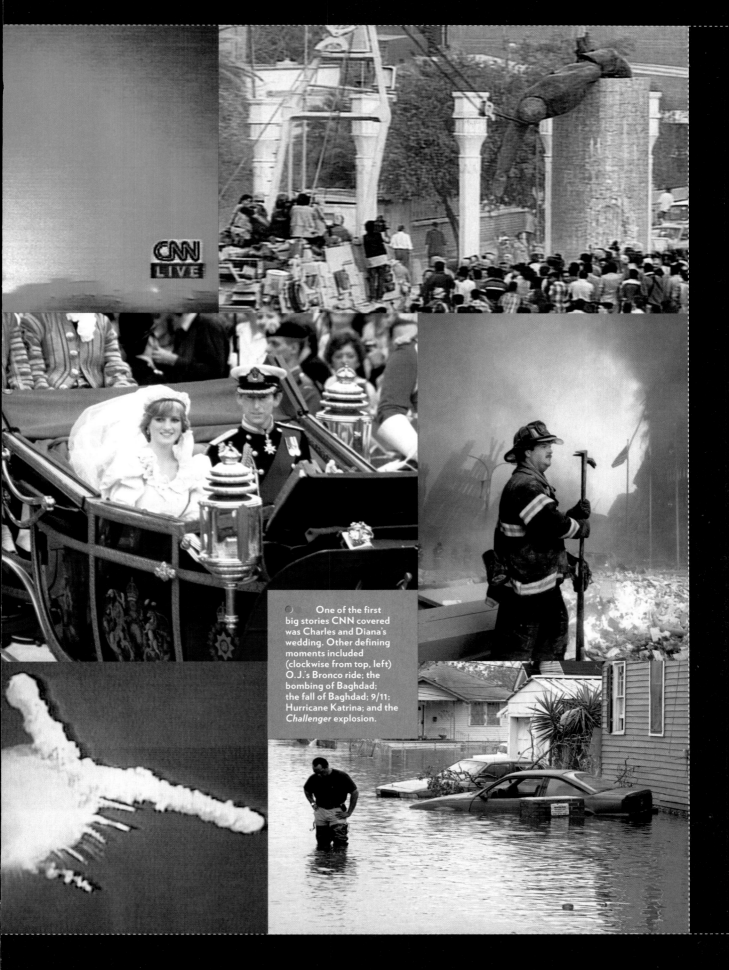

One of the first big stories CNN covered was Charles and Diana's wedding. Other defining moments included (clockwise from top, left) O.J.'s Bronco ride; the bombing of Baghdad; the fall of Baghdad; 9/11; Hurricane Katrina; and the *Challenger* explosion.

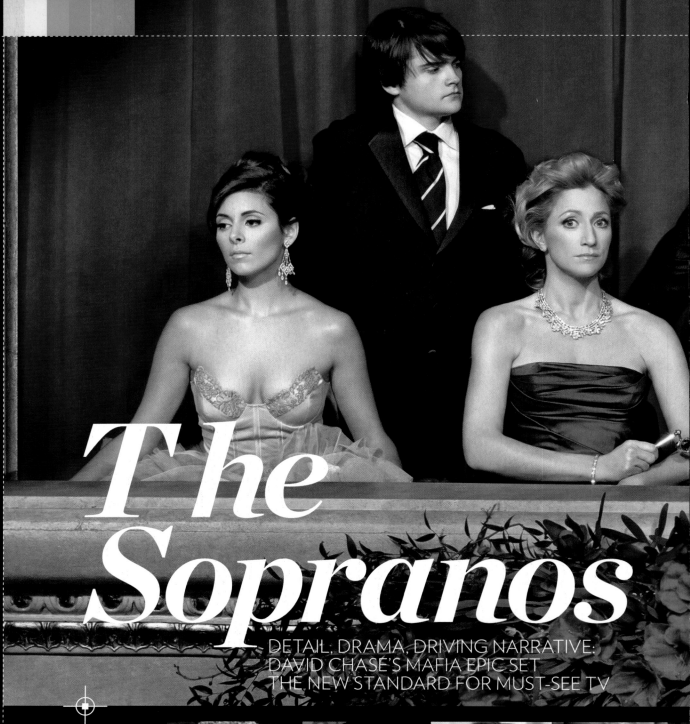

The Sopranos

DETAIL, DRAMA, DRIVING NARRATIVE:
DAVID CHASE'S MAFIA EPIC SET
THE NEW STANDARD FOR MUST-SEE TV

WHACK JOBS

If you weren't one of the ducks in his swimming pool, associating with Tony Soprano was a significant insurance risk. More than 90 characters died during *The Sopranos'* six seasons—and that's not counting Pie-O-My, Tony's horse.

●●● Big Pussy: Talked to the feds, shot by the crew, sleeps with the fishes.

Richie: Punches Tony's sis during a domestic dispute; she shoots him.

Ralphie: Strangled by Tony, head placed in bowling bag.

Tony Blundetto: Killed for killing without permission.

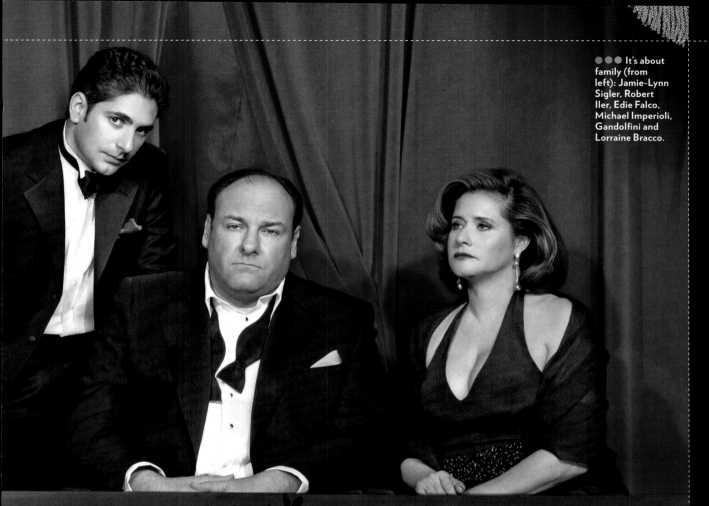

Writer-producer David Chase wanted to call his new HBO series *The Sopranos* after a family he'd known growing up, but HBO suggested the title *Family Man*. As Chase later recalled, "They thought people will say, 'It's about opera.'" Viewers figured out the difference fast enough: The New Jersey epic about Tony Soprano (James Gandolfini), a suburban Jersey mobster suffering from panic attacks, was *The Godfather* and *GoodFellas* extended into the realm of serial TV. (The networks passed on it, regardless of the name.) An immense, complicated narrative about humdrum lives full of crime, violence, sex, drugs, kitchen-counter meals and annoying (sometimes homicidal) in-laws and relatives, *The Sopranos* ran for 86 episodes over six seasons—Chase didn't like to be rushed—was awarded with 21 Emmys and was routinely hailed as the greatest TV show ever. Norman Mailer said it was as good as a novel. It sure wasn't sentimental: Major characters got whacked with some regularity, and a lot of brutality. Tony survived . . . probably. The show ended on June 10, 2007, with one of the most controversial closing shots in TV history: Tony, wife Carmela and their kids, Meadow and A.J., are eating out—or were they about to be rubbed out? The screen went black.

Vito: Loved the Mob; killed because he also loved men.

Phil Leotardo: Shot on Tony's orders; head crushed by SUV.

Cosette: Adriana's dog, died when Christopher, drugged-out, sat on her.

Adriana: Christopher's girlfriend, turned by the FBI, shot by Silvio.

Christopher: Tony's nephew, smothered when he becomes a liability.

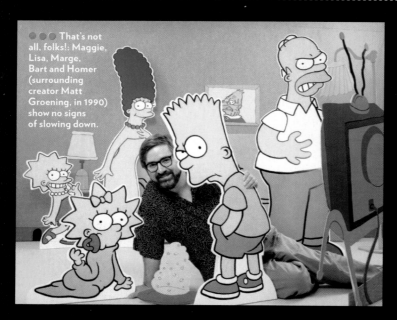

●●● That's not all, folks!: Maggie, Lisa, Marge, Bart and Homer (surrounding creator Matt Groening, in 1990) show no signs of slowing down.

The Simpsons

HIGH-CULTURE VICTORY! FOX'S KNOWING, RAPID-FIRE SATIRE KEEPS AMERICA GLUED TO THE ODYSSEY OF HOMER

Mooning the prime minister of Australia. Celebrating New Orleans as the "home of pirates, drunks and whores." Calling the French "cheese-eating surrender monkeys." It's been true since the beginning of time: If you're two-dimensional and yellow, you can get away with a *lot*. After more than 20 years and 460-plus episodes (the longest-running prime-time series), the uniquely American adventures of Homer, Marge, Bart, Lisa and Maggie have become a cultural artifact. Let's look at the numbers:

15: minutes cartoonist Matt Groening needed, while awaiting a 1986 meeting with Fox execs, to invent the Simpson family.

65-plus: recurring characters, including TV downer Krusty the Clown; nuclear plant owner Mr. Burns; insufferably cheerful neighbor Ned Flanders; and Kwik-E-Mart proprietor Apu Nahasapeemapetilon, Ph.D.

1/27/92: President George H.W. Bush says he hopes American families will become "a lot more like the Waltons and a lot less like the Simpsons."

2001: "D'oh" ("Expressing frustration at the realization that things have turned out badly or not as planned.") enters the online edition of the *Oxford English Dictionary*

$8 billion: estimated total merchandise revenue.

25: Emmy awards won.

1: Rank among 20th-century shows, per TIME.

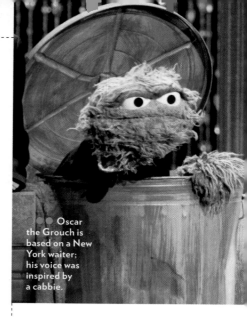

● Oscar the Grouch is based on a New York waiter; his voice was inspired by a cabbie.

Raised in the quiet confines of Romper Room, some parents didn't know what to make of a rowdy kiddie show set in a New York City brownstone where black kids and white kids hung out on the stoop and a garbage can housed a furry creature named Oscar the Grouch. But from the first episode, which aired Nov. 10, 1969, when a sock puppet named Kermit the Frog tried to explain the letter W to viewers as the Cookie Monster chewed it down to a V, children laughed and learned. Still some grown-ups fussed. "I can't fault the content," griped an educator. "I fault the presentation." Cue Elmo: That teacher needs a tickle.

●●● Open *Sesame*: Still stooping, 41 years later.

Sesame Street

FOR KIDS, PUPPETEER
JIM HENSON MADE
LEARNING FUN AND TV
A HAPPY REFUGE

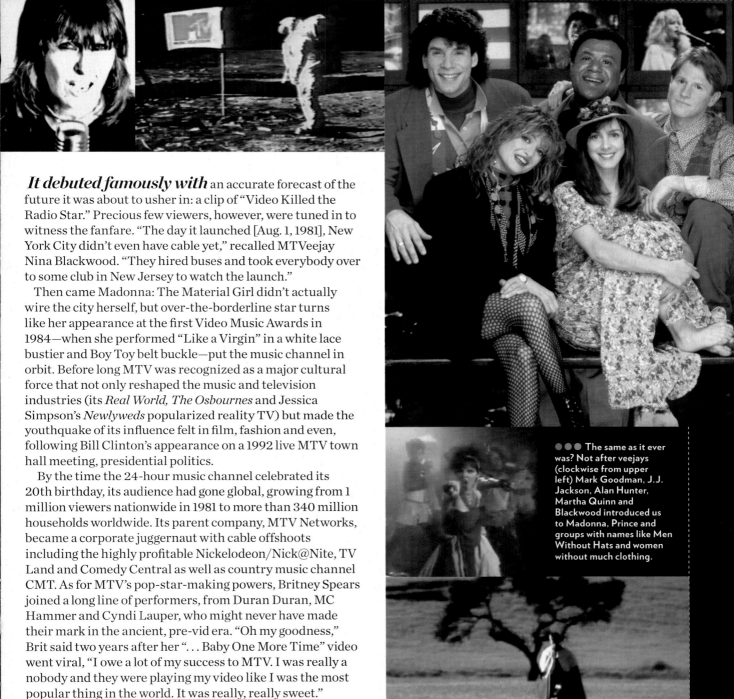

It debuted famously with an accurate forecast of the future it was about to usher in: a clip of "Video Killed the Radio Star." Precious few viewers, however, were tuned in to witness the fanfare. "The day it launched [Aug. 1, 1981], New York City didn't even have cable yet," recalled MTVeejay Nina Blackwood. "They hired buses and took everybody over to some club in New Jersey to watch the launch."

Then came Madonna: The Material Girl didn't actually wire the city herself, but over-the-borderline star turns like her appearance at the first Video Music Awards in 1984—when she performed "Like a Virgin" in a white lace bustier and Boy Toy belt buckle—put the music channel in orbit. Before long MTV was recognized as a major cultural force that not only reshaped the music and television industries (its *Real World, The Osbournes* and Jessica Simpson's *Newlyweds* popularized reality TV) but made the youthquake of its influence felt in film, fashion and even, following Bill Clinton's appearance on a 1992 live MTV town hall meeting, presidential politics.

By the time the 24-hour music channel celebrated its 20th birthday, its audience had gone global, growing from 1 million viewers nationwide in 1981 to more than 340 million households worldwide. Its parent company, MTV Networks, became a corporate juggernaut with cable offshoots including the highly profitable Nickelodeon/Nick@Nite, TV Land and Comedy Central as well as country music channel CMT. As for MTV's pop-star-making powers, Britney Spears joined a long line of performers, from Duran Duran, MC Hammer and Cyndi Lauper, who might never have made their mark in the ancient, pre-vid era. "Oh my goodness," Brit said two years after her ". . . Baby One More Time" video went viral, "I owe a lot of my success to MTV. I was really a nobody and they were playing my video like I was the most popular thing in the world. It was really, really sweet."

●●● The same as it ever was? Not after veejays (clockwise from upper left) Mark Goodman, J.J. Jackson, Alan Hunter, Martha Quinn and Blackwood introduced us to Madonna, Prince and groups with names like Men Without Hats and women without much clothing.

BEFORE MUSIC TELEVISION, WE USED TO WATCH ONE AND LISTEN TO THE OTHER

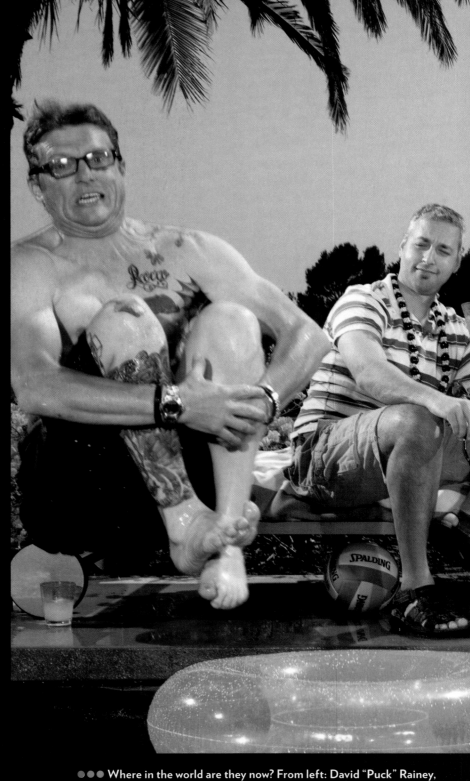

THROW STRANGERS INTO A HOUSE, ADD ALCOHOL, PRAY FOR FEUDS AND HOOKUPS: MTV'S UR-REALITY SHOW SPARKED A TV GENRE

Inspired, improbably, by an old show from that cauldron of hipness, PBS, MTV producers revolutionized television in 1992 when they stuck seven certain-to-clash twentywhatevers in a New York City loft and kept the cameras rolling. As in PBS's revolutionary *An American Family*, the results were unpredictable—and riveting. Early seasons paired southern whites and urban blacks, gays and homophobes. Most memorably, the show hit its zenith in 1994 when a gracious gay man suffering the final stages of AIDS lived under the same San Francisco roof with a boor named Puck, who set high the bar for outlandishly low behavior—a standard that most reality shows ever since have strived to surpass. Born of a lofty notion that its cameras would capture learning moments as well as gross-outs, *The Real World* tends now to emphasize the latter. Current versions, wrote one critic, are "pretty much just about getting hammered and hooking up."

●●● **Where in the world are they now? From left: David "Puck" Rainey, 42 (season 3; San Francisco), was badly injured in an auto accident near his home in San Diego in March 2010. *Real* gay pioneer Norman Korpi, 43 (season 1; New York City), is an artist in California. Soho house rocker Andre Comeau, 39 (season 1; N.Y.C.), still gigs with his band. Puck survivor Cory Murphy, 37 (season 3; San Francisco), is a mom and middle school teacher. Irene Barrera, 43 (season 2; Los Angeles), has remarried since splitting with the man she left the show to wed. Beth Stolarczyk, 41 (season 2; L.A.), can't get enough reality. After appearing in series spinoffs, she founded Planet Beth LLC, an agency that finds work for ex-reality stars.**

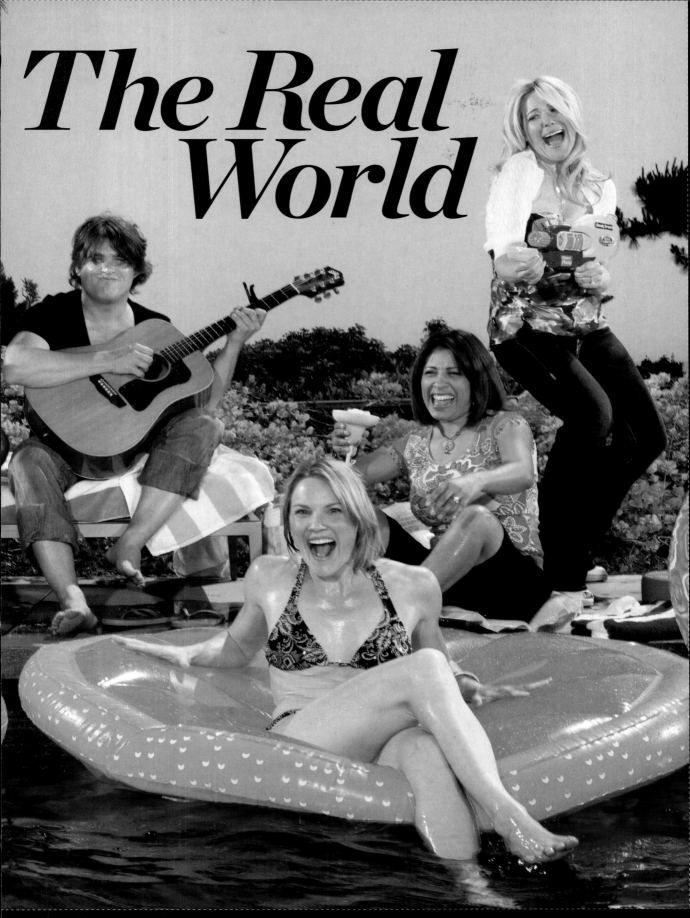

The Real World

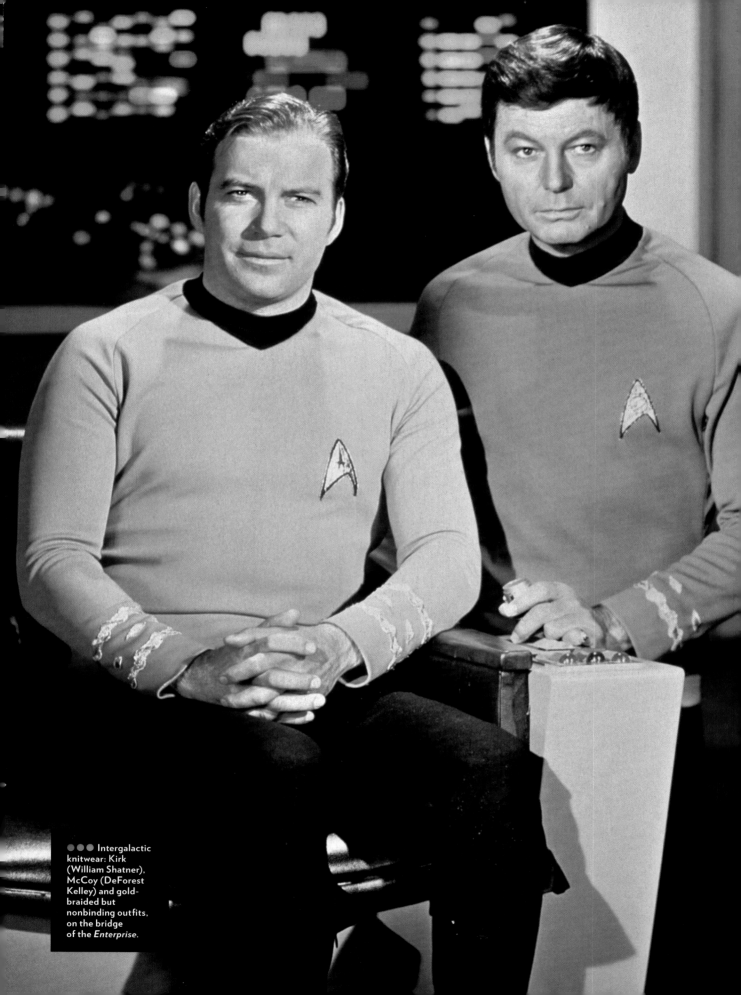

● ● ● Intergalactic
knitwear: Kirk
(William Shatner),
McCoy (DeForest
Kelley) and gold-
braided but
nonbinding outfits,
on the bridge
of the *Enterprise*.

CULT CLASSICS

As Capt. Kirk—er, William Shatner—pleaded while addressing a faux **Star Trek** convention on **Saturday Night Live** in 1986: "Get a life, will you people? For crying out loud it's just a TV show!" No, no it's not. And there's only one possible explanation for Kirk's outburst: It was really his Evil Twin, the one created by that transformer accident in episode 5, "The Enemy Within"! **Star Trek** is not *just* a show, and neither are a host of other series—from **X-Files** to **Buffy the Vampire Slayer** to **My So-Called Life**—whose fans made up in passion what they may often have lacked in cold, tyrannical Nielsen numbers. The shows are gone. Their reputations survive. Live long and prosper, Captain.

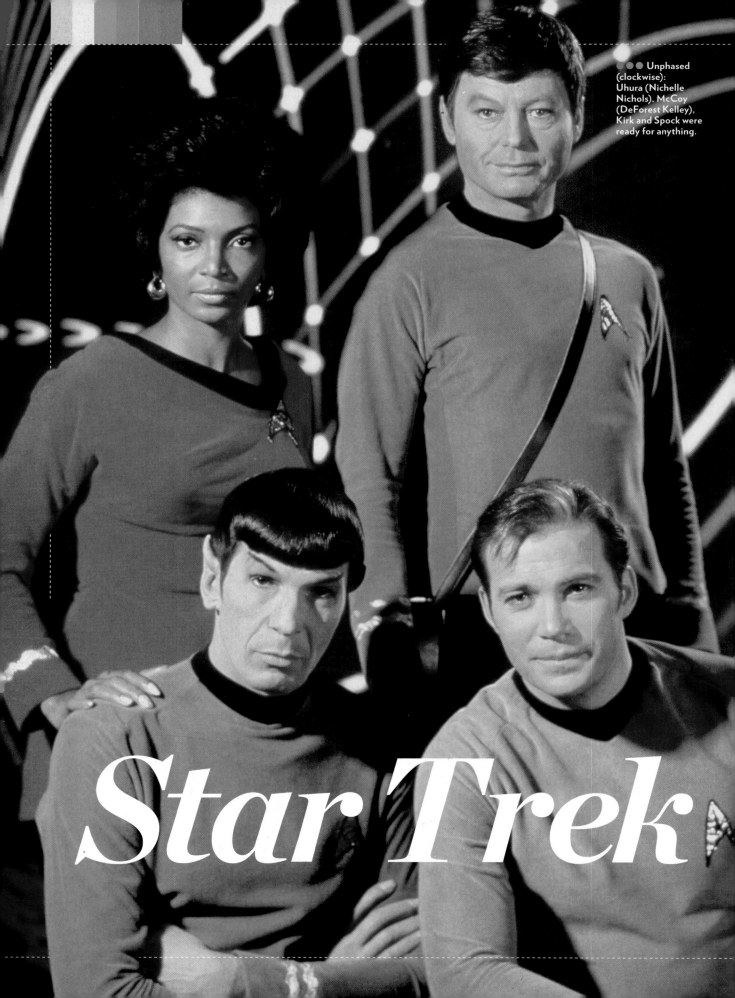

●●● Unphased (clockwise): Uhura (Nichelle Nichols), McCoy (DeForest Kelley), Kirk and Spock were ready for anything.

Star Trek

KIRK EMOTED, SPOCK DIDN'T, AND EVERYONE DRESSED IN THE COLORS OF '70s KITCHEN APPLIANCES IN THE SPACE WESTERN THAT STARTED IT ALL

They went boldly where no man had gone before . . . but they went a little too soon. *Star Trek* debuted in 1966 and drew a small, passionate audience but lousy overall ratings; 79 episodes later, NBC execs set their phasers on "obliterate."

Such was the inglorious start to a franchise that, to date, has spawned five TV series, 11 movies and hundreds of books, comics and Trekkie conventions. Over time, *Trek's* alchemy proved as irresistible as it was inexplicable: Who knew that an entertainment empire could be built on a foundation of latex aliens, low-tech effects, bravura bombast (Capt. Kirk: "Maybe we can't stroll to the music of lutes. We must march to the sound of drums") and Scottish-accented histrionics (Scotty: "I canna' change the laws of physics! I've gotta' have 30 minutes!")?

The journey began when Gene Roddenberry, an L.A. cop turned TV writer, imagined a western set in space. Building from John F. Kennedy's hopeful New Frontier, he envisioned an infinite Final Frontier explored by an idealistic multi-culti crew, a heroic captain (William Shatner) and his brilliant but emo-free half-alien sidekick, Mr. Spock (Leonard Nimoy). One big plus: An infinite universe allowed writers to dream up any possibility, from a planet whose entire population dressed like 1920s Chicago gangsters to an alien ambassador whose visage caused insanity. That giddy freedom may have played a role in the 1968 episode where Captain Kirk kissed Lieutenant Uhura—often cited as the first interracial smooch on American television.

In 1979 *Star Trek: The Motion Picture* earned $80 million and revived the *Enterprise.* Of the TV series that followed, *Star Trek: The Next Generation,* which lasted from 1987 to 1994 and starred Patrick Stewart as the cerebral Capt. Jean-Luc Picard, did the most to reinvent the franchise.

In an infinite universe, all things are possible. In fact many of them occurred: Kim Cattrall, pre-*Sex and the City,* played a Vulcan lieutenant in the sixth *Star Trek* movie; Leonard Nimoy once wrote and released an album on which he sings "Music to Watch Space Girls By"; and actor George Takei—Mr. Sulu—later served on a Southern California transit board.

Less surprising, but nice to know: Gene Roddenberry's remains—he died in 1991—are slated to be shot into space in 2012.

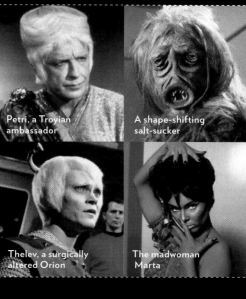

X-Files

FOX'S SUPER SPOOKFEST BOASTED
CHARISMATIC STARS, SHARP SCRIPTS AND
(NO JOKE) A MAGGOT WRANGLER

●●● Satanists,
mutants and zombies,
oh my!: Duchovny
(left) and Anderson
hung with the fun crowd.

They were all in on it. Surfer-turned-journalist-turned-TV producer Chris Carter. Theretofore unknown actors David Duchovny and Gillian Anderson. And they were merely figureheads for a veritable Grassy Knoll of odd characters (Cigarette Smoking Man; the Lone Gunmen), UFO-borne aliens, terrifying crimes and a conspiracy so dark and vast it could only stem from the secret depths of government gone awry.

Why, oh, why must we always have a bureaucrat standing between us and our space aliens?

This was the question looming over *The X-Files* when the supernatural cop show premiered in 1993. Set among a special team of FBI agents tasked with researching and resolving the agency's least explicable crimes, the show followed faith-based investigator Fox Mulder (Duchovny) and the science-trained Dana Scully (Anderson) through a wild array of way-past-creepy crimes.

The X-Files was a quick and lasting hit, eventually launching a mid-run feature film (*Fight the Future,* 1998) and surviving cast changes (Duchovny all but left the show in 2000), then found an afterlife in a short-lived spinoff series (2001's *The Lone Gunmen*) and a reunion film (*I Want to Believe,* 2008). The trail of the original series vanished in 2002, but as any alien-savvy believer knows, you never can tell when they're coming back.

Will the *X* plot continue? Only Carter knows for sure, and he's not telling.

"That way," he says, "they can't get rid of me."

CREEP FACTOR

"Often when I read the scripts I get freaked out, creeped out," said Gillian Anderson. She wasn't the only one. The most memorable *X-Files* episodes left viewers downright . . . disturbed.

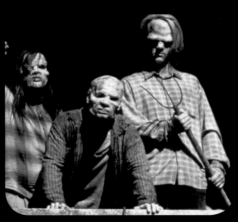

2 "Shy" features a serial killer with the unseemly habit of digesting his overweight victims' fatty tissues. As Scully put it: "He's some kind of fat-sucking vampire?"

3 In "The Host" Mulder is sent to investigate a body washed into the New Jersey sewer and soon discovers a giant predatory fluke worm that attaches itself and feeds off humans.

1 "Home," the only *X-Files* episode banned from network reruns, centered around a family that had been inbreeding for generations.

4 "Irresistible" is about death fetishist and mortuary worker Donnie Pfaster, who collected fingernails and hair from his female victims.

Buffy
the Vampire Slayer

TODAY'S TO-DO: GO TO CLASS, STALK THE UNDEAD, REMEMBER MATH HOMEWORK!

Before Twilight, **before** True Blood, there was Buffy. She slayed vampires after homeroom, her BFF was a lesbian Wiccan (played wittily by Alyson Hannigan), and fashion accessories ran to crucifixes and scythes. Sarah Michelle Gellar's Buffy may have never let her highlights fade, but as "the Chosen One"—the once-a-generation girl destined to be a slayer—vanquishing demons was her mandate: Her hometown of Sunnydale, Calif., was located directly above a "Hellmouth."

Adapted from a goofy movie of the same name, Buffy had nothing in common with it other than creator Joss Whedon. On TV, Buffy was serious about her slaying and her dating life. The show's power derived from its tough-to-nail mix of coming-of-age insecurities and intricate vampire-werewolf-witch lore. Viewer response tended to be binary: You either loved it or shrugged. The series, wrote an ENTERTAINMENT WEEKLY critic, "allowed us to look at ourselves through a fantastical lens and see who we truly are: at once stronger than we thought we could be and weaker than we'd like to let on. And, as with most great genre fiction, the establishment just didn't get it."

SUPERFANS

Buffy hopscot0ched through genres while keeping its sense of humor intact and lighting a path for others to follow. Proof that it got in your blood? The fan base included a future brain trust of Hollywood players:

J.J. Abrams
Lost co-creator–executive producer; *Star Trek* and *Mission: Impossible III* director: "I admire and enjoy *Buffy* immensely." His *Lost* co-creator–executive producer Damon Lindelof also admitted that certain *Lost* episodes were heavily influenced by the TV's stake crusader.

Shonda Rhimes
Creator–executive producer of *Grey's Anatomy, Private Practice*: "The language was great, the world was great, and you completely invested in those characters. I'm still not over its cancellation."

Amy Sherman-Palladino
Creator–executive producer of *Gilmore Girls*: Despite her *Girls* competing with *Buffy* for TV ratings in 2001, "I've been a *Buffy* fanatic for years as well as a huge fan of [series creator] Joss Whedon's writing."

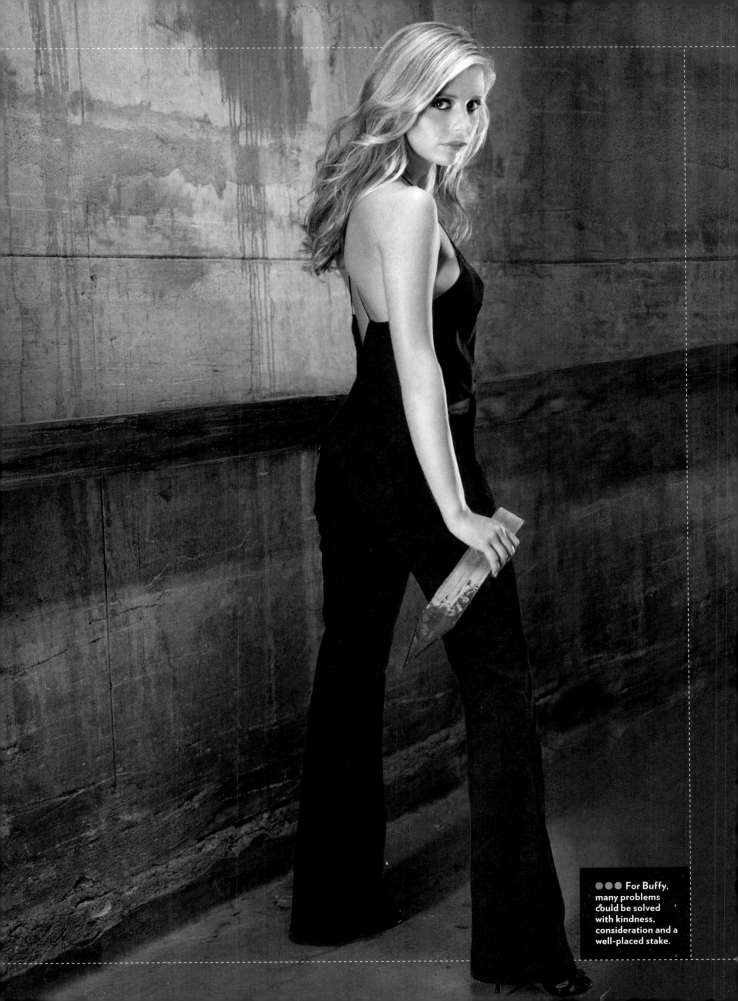

●●● For Buffy, many problems could be solved with kindness, consideration and a well-placed stake.

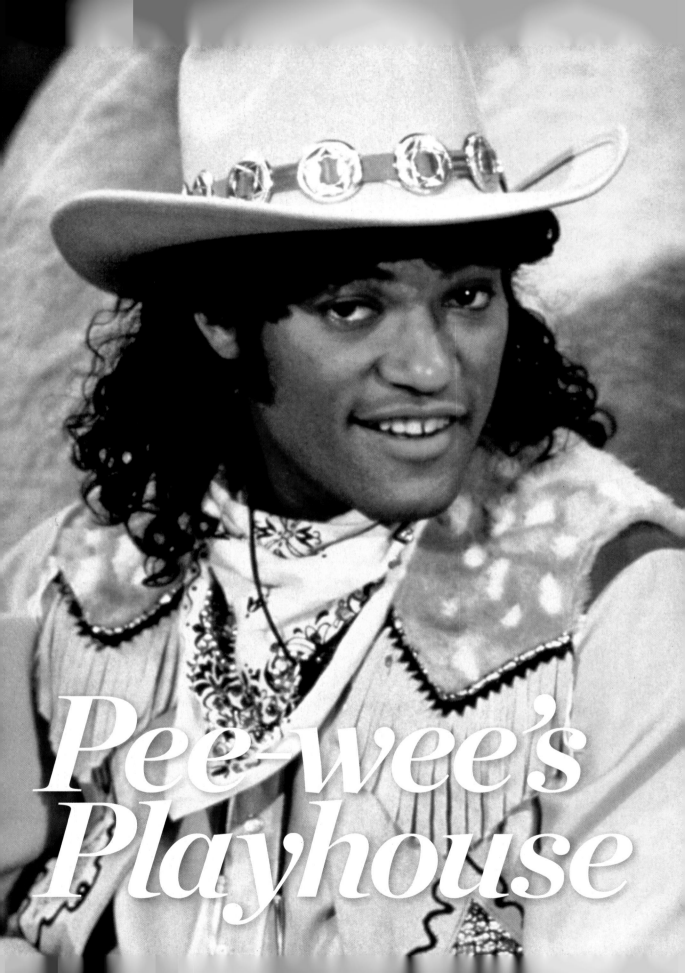

Pee-wee's Playhouse

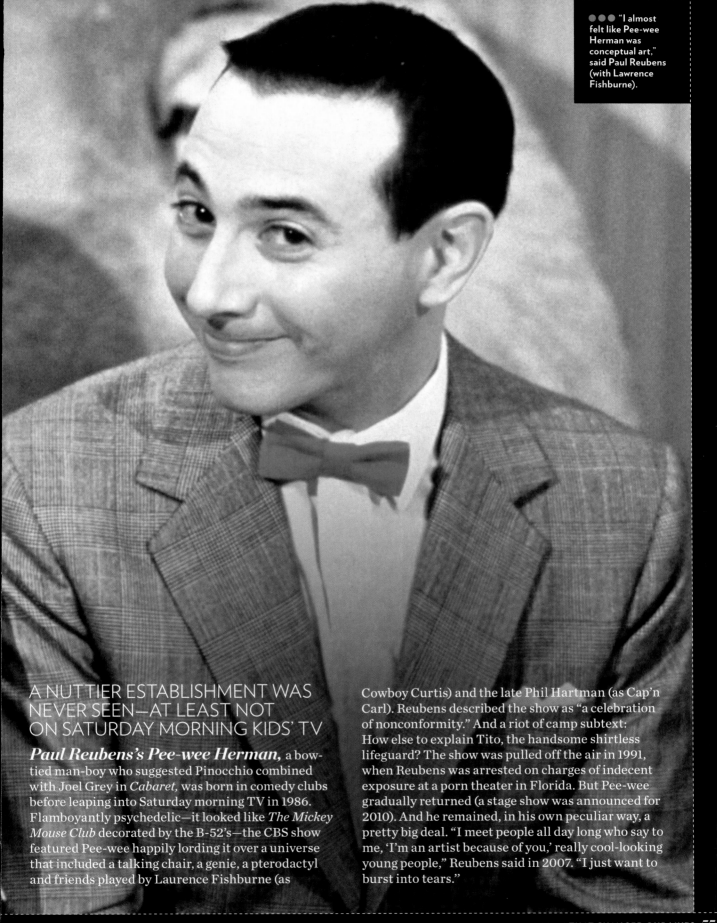

A NUTTIER ESTABLISHMENT WAS NEVER SEEN—AT LEAST NOT ON SATURDAY MORNING KIDS' TV

Paul Reubens's Pee-wee Herman, a bow-tied man-boy who suggested Pinocchio combined with Joel Grey in *Cabaret,* was born in comedy clubs before leaping into Saturday morning TV in 1986. Flamboyantly psychedelic—it looked like *The Mickey Mouse Club* decorated by the B-52's—the CBS show featured Pee-wee happily lording it over a universe that included a talking chair, a genie, a pterodactyl and friends played by Laurence Fishburne (as Cowboy Curtis) and the late Phil Hartman (as Cap'n Carl). Reubens described the show as "a celebration of nonconformity." And a riot of camp subtext: How else to explain Tito, the handsome shirtless lifeguard? The show was pulled off the air in 1991, when Reubens was arrested on charges of indecent exposure at a porn theater in Florida. But Pee-wee gradually returned (a stage show was announced for 2010). And he remained, in his own peculiar way, a pretty big deal. "I meet people all day long who say to me, 'I'm an artist because of you,' really cool-looking young people," Reubens said in 2007. "I just want to burst into tears."

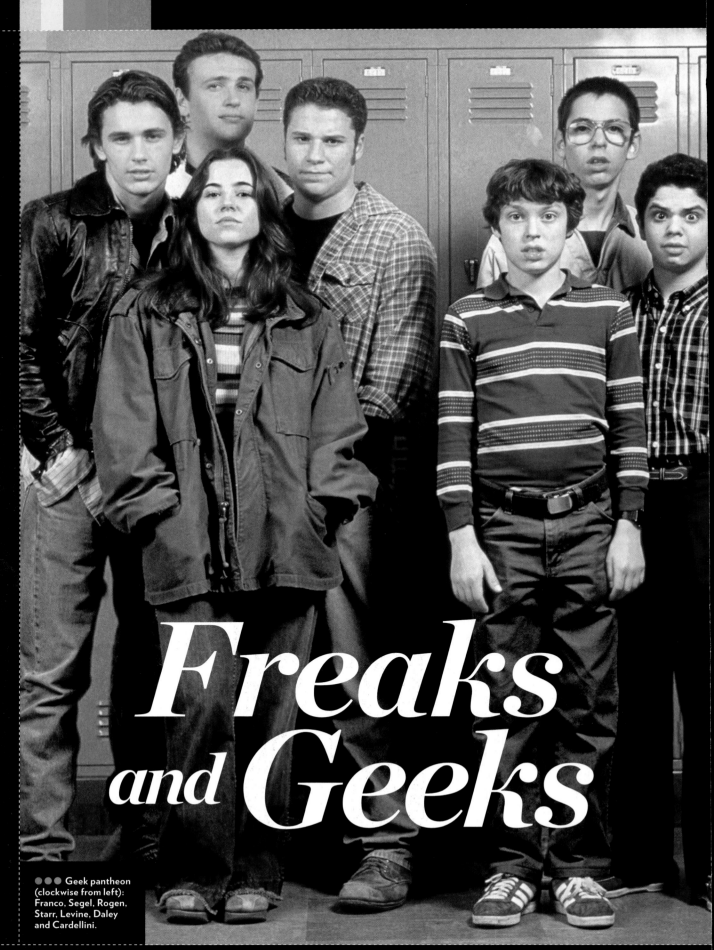

Freaks and Geeks

GREAT REVIEWS.
A CAST OF
STARS-TO-BE.
COMEDY GOD
JUDD APATOW'S
'BEST WORK.'
AND: DEAD IN 18
EPISODES

A critical fave, a hit with the cool kids and the launchpad for producer Judd Apatow's career (and, it seems, a fair proportion of young Hollywood; see below), *Freaks and Geeks* will go down in TV history as one of the genre's most successful failures. "The majority of adults didn't want to watch a show about kids," theorized one critic about the show's miniscule one-season lifespan, "and the majority of kids didn't want to watch a show about the early '80s."

Set in circa 1980 Michigan, *Freaks* featured A-student and mathlete Lindsay Weir (Linda Cardellini), who sloughs off her good-girl persona to hang with the freaks, while younger brother Sam (John Francis Daley) remains fully ensconced in his geekdom. Charming, clever and outrageous, *F&G* captured the era with perfect pop-cultural pitch (Atari! Steve Martin's "King Tut"!). Perhaps the show was simply ahead of its time. A decade later, *Glee* brought freaks and geeks together in the music room, and the crowds went wild.

FREAKS NO MORE

Sure, they were freaks and geeks, but NBC's cancellation could not stem their march to glory. Most of McKinley's misfits—often with a turbo-boost from producer Judd Apatow (*40-Year-Old Virgin, Knocked Up*) have found success after high school.

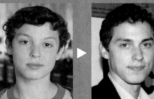

Linda Cardellini
McKinley's mathlete stole scenes in *Legally Blonde* and *Scooby-Doo* and spent five seasons as *ER* nurse Samantha Taggart.

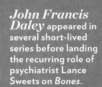

Busy Philipps
Freaks' resident mean girl went from *Dawson's Creek* to *ER*; now plays Courteney Cox's ditzy BFF on *Cougar Town.*

John Francis Daley appeared in several short-lived series before landing the recurring role of psychiatrist Lance Sweets on *Bones.*

Seth Rogen is everywhere, all the time: *The 40-Year-Old Virgin, Knocked Up, Superbad* (which he cowrote) and *The Green Hornet.*

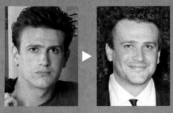

Jason Segel is busy: plays Marshall on *How I Met Your Mother*; wrote and starred in *Forgetting Sarah Marshall*; writing the next Muppet movie.

Samm Levine
Once the inexplicably confident geek Neal Schweiber, Levine appeared in Quentin Tarantino's *Inglourious Basterds.*

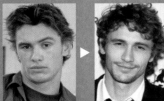

James Franco
Unpredictable: roles in *Spider-Man, Milk* and *Pineapple Express*, then the soap *General Hospital*; now in grad school.

Martin Starr worked his *Freaks* connection for bit parts in *Knocked Up* and *Superbad*; currently appears on Starz's *Party Down.*

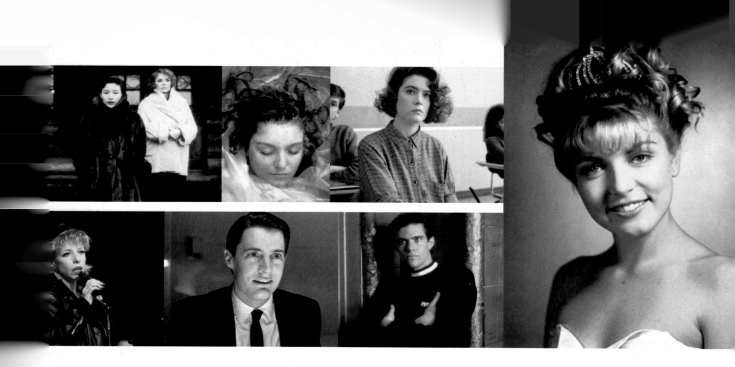

Twin Peaks

A SURREAL SERIES PRESENTED TWO MYSTERIES: WHODUNIT AND, ER . . . WHATWASIT?

Who killed homecoming queen Laura Palmer and left her naked corpse wrapped in plastic? That was the mystery that launched the most daringly eccentric drama ever to air on network television. Laura's death wasn't the only riddle that baffled and sometimes infuriated visitors to Twin Peaks, an oddly sinister Northwest town co-created by *Blue Velvet* director David Lynch. Who, for instance, was that woman cradling a log in her arms? Why was eye-patch–wearing Nadine so obsessed with drapes? And what about the dwarf who appeared in a debauched-party dreamscape? Before its premiere on ABC as a two-hour movie in 1990, one ad executive warned, "I don't think it has a chance of succeeding."

The premiere, though, was critically acclaimed and enough of a hit to lead to a series commitment—somehow it lasted for 30 episodes, even while the public lost interest in the show's ambling perverseness. By the time Laura's mystery was solved (sort of) no one was asking anymore. But the show's otherworldly sense of dread, absurd humor and even beauty made it unforgettable—TIME listed it as one of the 100 greatest series ever. Lynch didn't especially care who killed Laura, anyway. "As soon as a show has a sense of closure," he said, "it gives you an excuse to forget you've seen the damn thing."

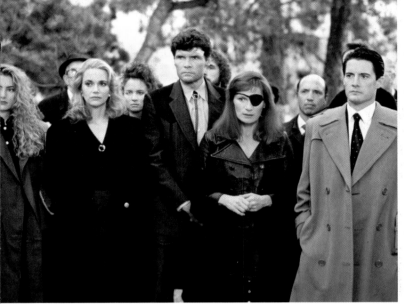

● ● ● *Peaks* haunted viewers' synapses and disturbed their sleep. Off-kilter characters included a coffee- and pie-obsessed FBI agent; mysteriously mature teens; a clairvoyant who lugged a log wherever she roamed; a demonic, mirror-haunting spirit named BOB; and a spooky dwarf who seemed to talk in tongues.

My So-Called Life

NAVIGATING
THE COMPLEX
EMOTIONS
AND ENDLESS
HALLWAYS OF
ADOLESCENCE,
FANS IN TOW

Say "Jordan Catalano" in a roomful of Gen-X women, watch their eyes go dreamy and listen for the sighs.

Produced by *thirtysomething*'s Marshall Herskovitz and Ed Zwick, *Life* lasted only 19 episodes, but its impact lives on. The show centered on Claire Danes as Angela Chase, a Pittsburgh-area high schooler desperately navigating teen angst and ennui. Her crush on Jared Leto's Jordan Catalano, the languid hunk who'd been "held back—twice," made puppy love feel as urgent as a fire alarm. Rounding out the cast were wild-child Rayanne (A.J. Langer) and the discovering-he's-gay Rickie, whose story mirrored the real experience of actor Wilson Cruz. ("On Christmas Eve of '93, I came out to my dad," he said later. "He kicked me out. I lived in my car . . . [until] we started filming the series.") Danes, only 13 when she taped the pilot, recalls that there were benefits to exploring adolescence onscreen: "I mean, I had Jared Leto teaching me how to make out."

"I'm profoundly grateful for the show," she said in 2004, nine years after *Life*, as fans knew it, ended. "It was really special."

The Larry Sanders Show

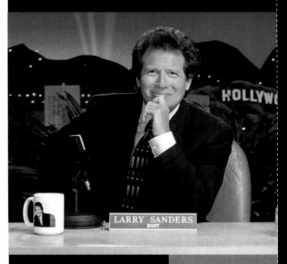

Comic Garry Shandling grabbed the host's seat on an ersatz fake talk show.

SO-CALLED GRADS

Fifteen years after leaving an indelible and angst-ridden mark on pop culture, *So-Called*'s teens are all grown up:

Now-31-year-old Claire Danes's portrayal of Angela Chase launched a career that includes starring roles in blockbusters (*Terminator 3: Rise of the Machines*), indies (*Stage Beauty*) and on Broadway (*My Fair Lady*).

As a gay teen coming to terms with himself, actor Wilson Cruz lived the TV character he played. Now 36, he works in TV and film and is active in the LGBT community.

Still into hyphens, Jared Leto, 38, has gone from sensitive-bad-boy slacker to actor-rocker: These days he splits time between film and TV work, and as the frontman of rock band Thirty Seconds to Mars.

A.J. Langer, now 36, traded Rayanne's free-spirited, bad girl attitude for aristocracy: In 2005 the actress wed Charlie Courtenay, the future Earl of Devon. The couple will someday live in Courtenay's ancestral home, Powderham Castle, in Devon, England.

Taking a Ginsu knife to neurotic showbiz types, Garry Shandling redefined TV satire with HBO's *The Larry Sanders Show*, the first pay-cable series to score a Best Comedy Emmy nod. A wicked riff on late-night talk shows, it blurred the line between real and TV life: Shandling turned down offers for his own late-night gig to play paranoid, thin-skinned host Larry Sanders in an innovative show-within-a-show format (hey, Garry, *30 Rock* called— they say thanks!). Debuting in 1992, it mixed surreal cameos by real-life "guests" (David Duchovny's awkward man-crush on Larry) with indelible comic turns by its cast: Jeffrey Tambor as pompous sidekick Hank; Rip Torn as eat-his-young producer Artie ("I killed a man like you in Korea," he tells one female exec). "Doing a real talk show would have been unfulfilling," Shandling later explained. Instead, in just six seasons, his bumper-car ballet of egos all but created cringe comedy.

●●● You have turned the page to a show like no other, one that ran for five seasons (1959-64) on CBS. It existed without color and before cable or even PEOPLE, but not before William Shatner, who appeared in the 1963 episode "Nightmare at 20,000 Feet." He was but one of dozens of stars and stars-to-be who were lured every week into an eerie, unpredictable realm called . . .

The TWILIGHT ZONE

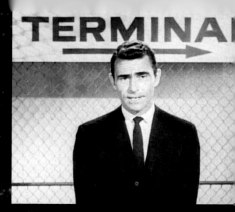

Zone master: Chief writer (and prime mover) Rod Serling opened every episode.

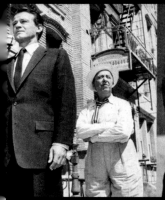

Salesman Ed Wynn (right) outsmarts "Mr. Death."

Time-traveling Pat Hingle relives his childhood—beatings by bullies and all.

Elizabeth Montgomery played a bewitching Cold War Russian.

Dennis Hopper appeared as a bush-league Führer.

Beauty, one famous plot twist suggested, depends on what planet you're on.

Sue Cummings discovered *To Serve Man* is a cookbook.

Carol Burnett (with Jesse White) got laughs in a comic *Zone.*

Pre-*Bandit*: Burt Reynolds (left) played a Shakespearean actor.

Comedian Shelley Berman rode a subway car full of himself.

Robert Redford was the not-so-grim-looking Reaper.

Shatner (with Patricia Breslin) was mesmerized by a tabletop toy.

Newsman Burgess Meredith's scoops raised hell.

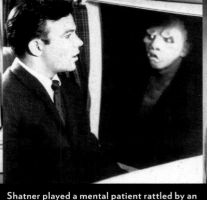

Lois Nettleton coped with global warming in "Midnight Sun."

Shatner played a mental patient rattled by an in-flight hallucination—which proved real.

Jack Klugman's pool hustler shot it out with a dead man.

Invading another planet, earthlings found a giant Agnes Moorehead.

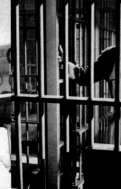

James Whitmore's Utopian dream came true.

Roddy McDowall (with Susan Oliver) found Martians liked us.

Death stalked Inger Stevens on a cross-country road trip.

Lunar astronaut Earl Holliman failed a big test in *Twilight*'s first episode.

Cloris Leachman mothered an evil, all-powerful mutant.

Drunken department store Santa Art Carney's wishes came true on Christmas Eve in "The Night of the Meek."

Barbara Nichols was a stripper saved by a nightmare.

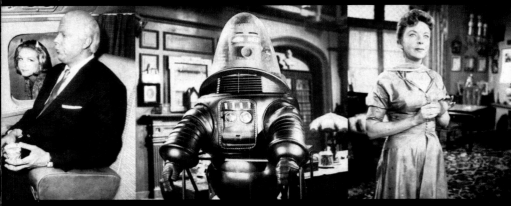

Julie Newmar's devil rode the rails.

Future *Lost in Space* robot Bob May honed his 'droid skills in the *Zone*.

Ida Lupino played a fading film queen lost in her own legend.

Burgess Meredith was the last man alive after the Bomb.

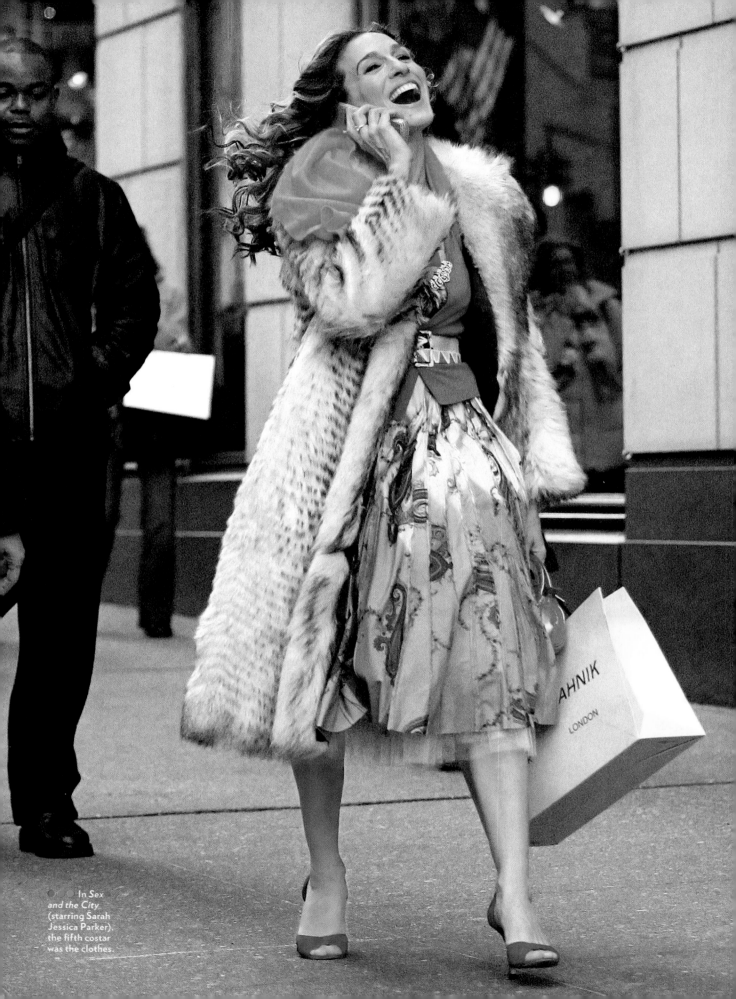

In *Sex and the City* (starring Sarah Jessica Parker), the fifth costar was the clothes.

FASHION

In some ways it's like an archeological dig. Find the telltale artifact, and you can date the TV show. Leg warmers? **Fame**, ca. 1982. Pastel, on men? **Miami Vice**, ca. 1984. Animal-print knee-length tunic? Fred Flintstone, early paleolithic era. Only shoulder pads cause chronological confusion: Big pads? Professional football, on any Sunday. BIGGER pads? Joan Collins and Linda Evans, **Dynasty**, 1981-89.

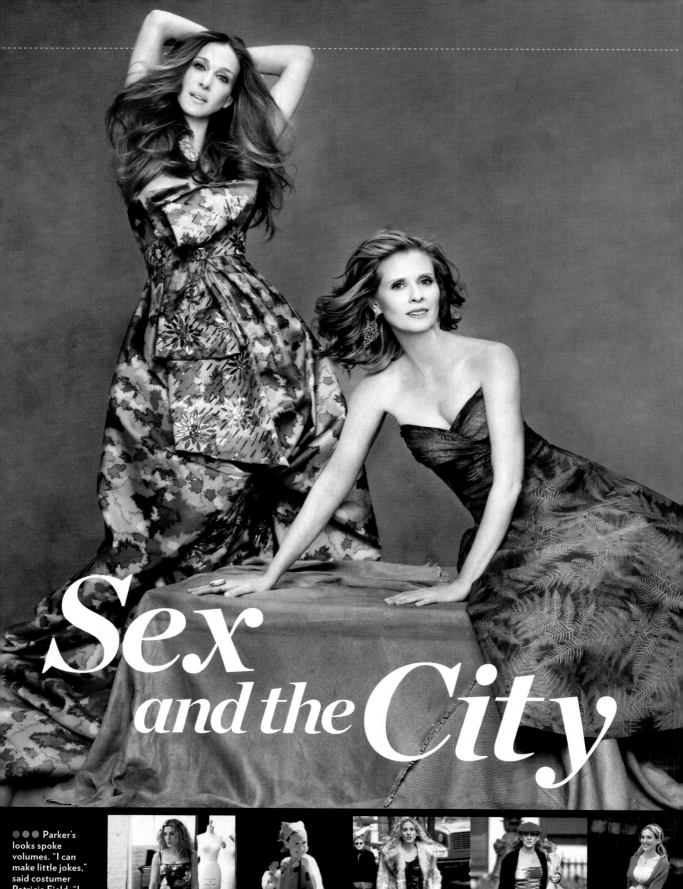

Sex and the City

● ● ● Parker's looks spoke volumes. "I can make little jokes," said costumer Patricia Field. "I know how to speak to [the audience] in the language of the wardrobe."

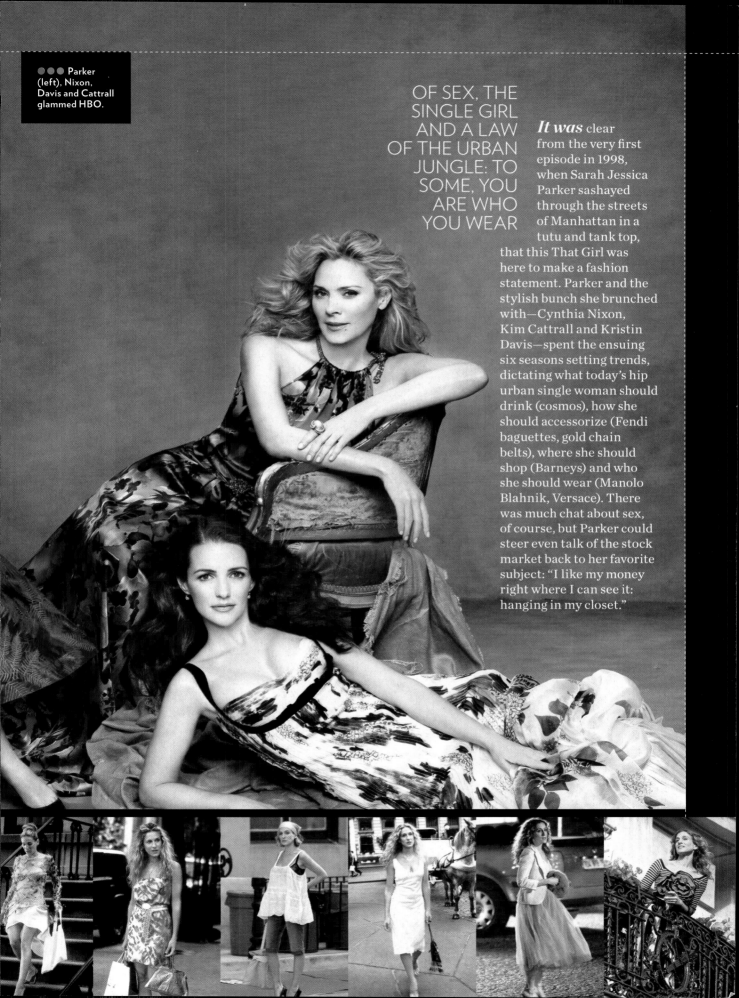

OF SEX, THE SINGLE GIRL AND A LAW OF THE URBAN JUNGLE: TO SOME, YOU ARE WHO YOU WEAR

It was clear from the very first episode in 1998, when Sarah Jessica Parker sashayed through the streets of Manhattan in a tutu and tank top, that this That Girl was here to make a fashion statement. Parker and the stylish bunch she brunched with—Cynthia Nixon, Kim Cattrall and Kristin Davis—spent the ensuing six seasons setting trends, dictating what today's hip urban single woman should drink (cosmos), how she should accessorize (Fendi baguettes, gold chain belts), where she should shop (Barneys) and who she should wear (Manolo Blahnik, Versace). There was much chat about sex, of course, but Parker could steer even talk of the stock market back to her favorite subject: "I like my money right where I can see it: hanging in my closet."

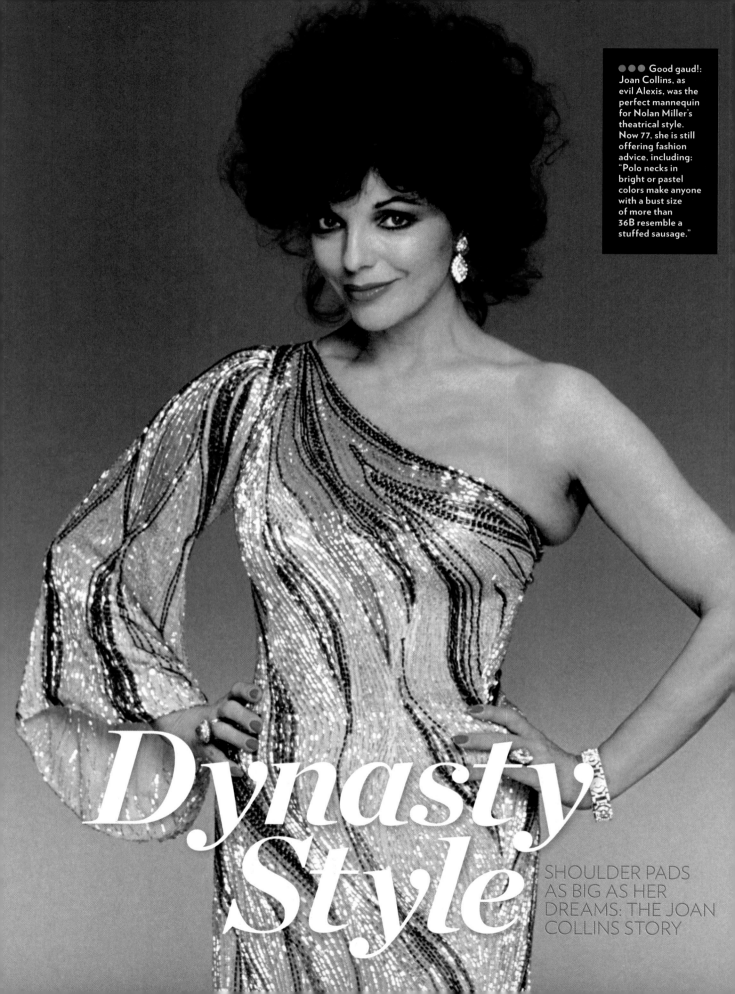

Dynasty Style

SHOULDER PADS AS BIG AS HER DREAMS: THE JOAN COLLINS STORY

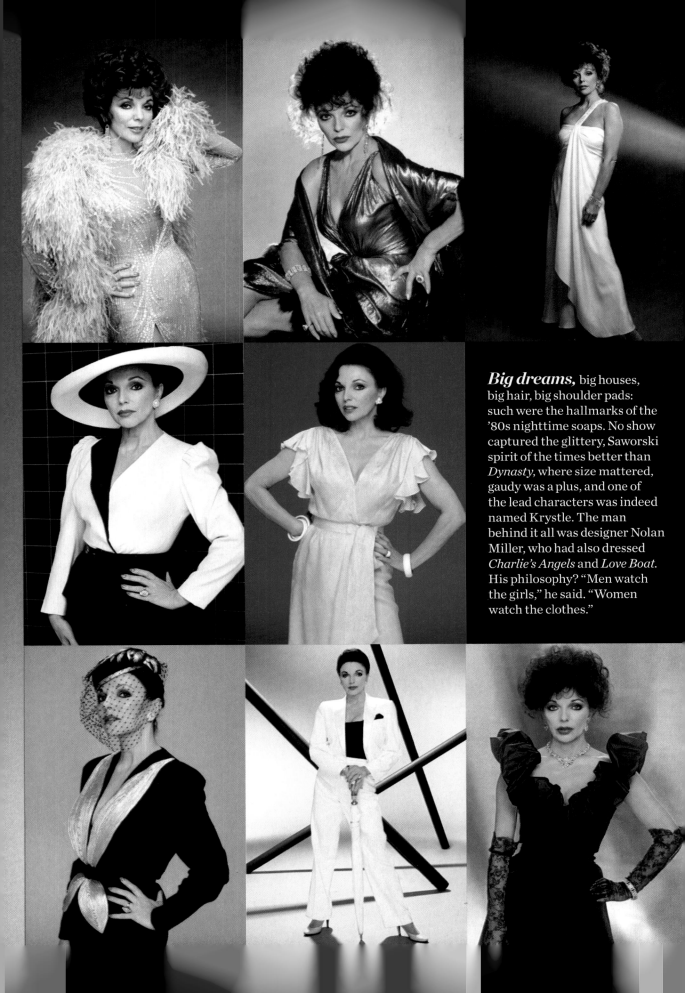

Big dreams, big houses, big hair, big shoulder pads: such were the hallmarks of the '80s nighttime soaps. No show captured the glittery, Saworski spirit of the times better than *Dynasty*, where size mattered, gaudy was a plus, and one of the lead characters was indeed named Krystle. The man behind it all was designer Nolan Miller, who had also dressed *Charlie's Angels* and *Love Boat*. His philosophy? "Men watch the girls," he said. "Women watch the clothes."

The '80s... An Era of Broad Shoulders

●●● The '80s. A time when greed was good. Mergers merged and acquisitioners acquired. And too much was seldom enough, especially when it came to . . . shoulder pads? Popularized by Linda Evans and Joan Collins, they became the female power symbol—analogous to military epaulets, perhaps?— of the nighttime soaps (clockwise from top left: Morgan Fairchild in *Paper Dolls* and, from *Dynasty*, Catherine Oxenberg, Linda Evans, Pamela Bellwood, Heather Locklear and Pamela Sue Martin). A variable look, shoulder pads could say, depending on the mien of the wearer, either "come hither" or "get out of my way or I'll knock you over like a nine pin."

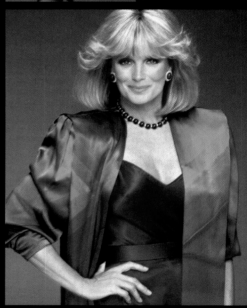

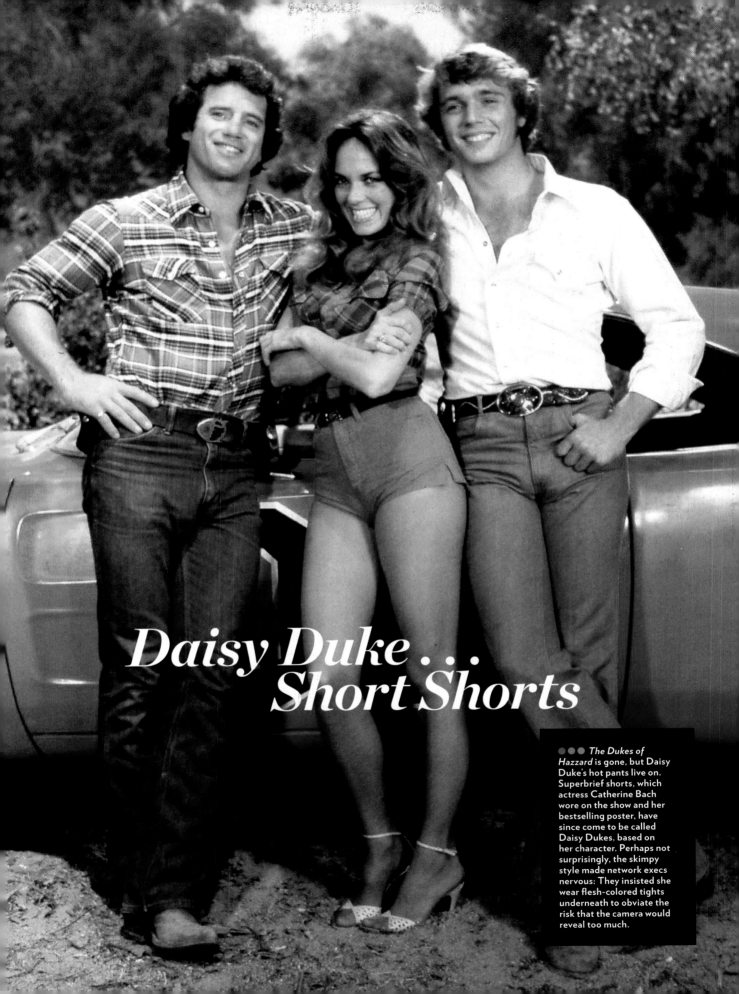

Daisy Duke . . . Short Shorts

●●● *The Dukes of Hazzard* is gone, but Daisy Duke's hot pants live on. Superbrief shorts, which actress Catherine Bach wore on the show and her bestselling poster, have since come to be called Daisy Dukes, based on her character. Perhaps not surprisingly, the skimpy style made network execs nervous: They insisted she wear flesh-colored tights underneath to obviate the risk that the camera would reveal too much.

Miami Vice...
Sun and fun!

●●● Anything can happen in a fast-moving crime-and-nightlife capital—and Crockett and Tubbs are ready for it in sophisticated casual wear that goes from work to play without breaking a sweat! Crockett opts for summer-weight pants and an ultracool pink top for a look that says, "Hey, who's ready for piña coladas?" Still, ever the professional, he cleverly offsets his stripped-down style with a single accessory—a very large gun—that says, "And I mean business!" without his uttering a word.

Tubbs, clearly dressed for a serious event—perhaps the opera or a funeral—opts for *Miami Vice* formal wear: a *black* tank top. Fashion conscious to a fault, both men strictly adhere to an unbreakable rule: Sleeves between Memorial Day and Labor Day are a fashion faux pas.

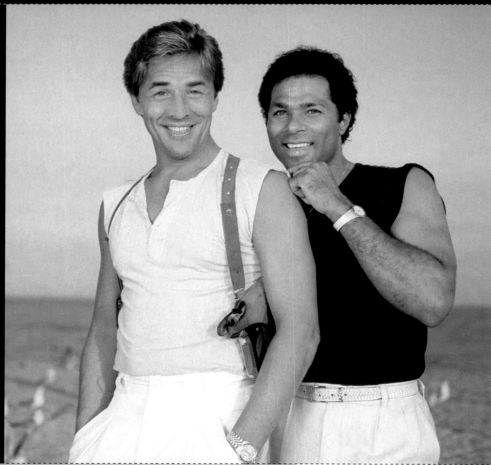

Fame...
Leg Warmers

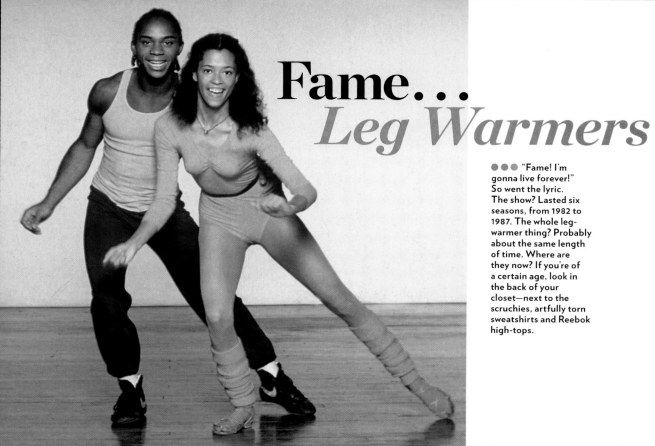

●●● "Fame! I'm gonna live forever!" So went the lyric. The show? Lasted six seasons, from 1982 to 1987. The whole leg-warmer thing? Probably about the same length of time. Where are they now? If you're of a certain age, look in the back of your closet—next to the scruchies, artfully torn sweatshirts and Reebok high-tops.

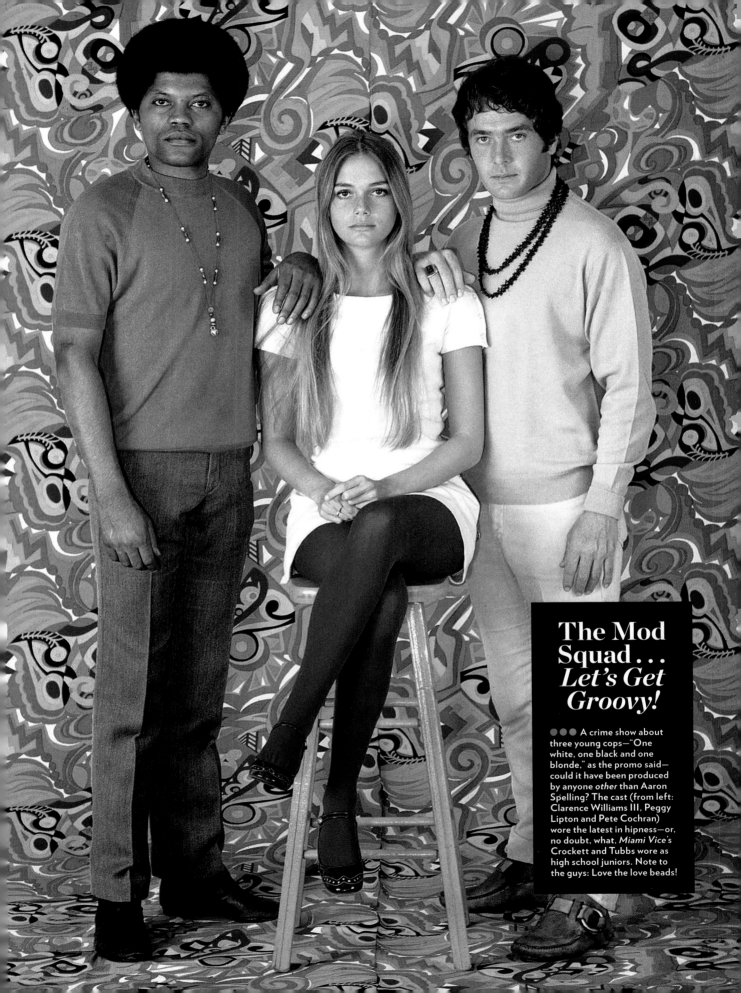

The Mod Squad... *Let's Get Groovy!*

●●● A crime show about three young cops—"One white, one black and one blonde," as the promo said— could it have been produced by anyone *other* than Aaron Spelling? The cast (from left: Clarence Williams III, Peggy Lipton and Pete Cochran) wore the latest in hipness—or, no doubt, what, *Miami Vice's* Crockett and Tubbs wore as high school juniors. Note to the guys: Love the love beads!

Ally McBeal...
Miniskirts

●●● Like any good lawyer show, *Ally McBeal* sparked debate—though not, usually, about legal issues. A still unresolved question, probably working its way to the Supreme Court even now: *Were* her oft-worn miniskirts too short for the workplace? Were they, in fact, *micro*-minis? Or, as some scientists have suggested, even *nano*-minis?

Ashton's...
Trucker Hat

●●● It was actually Ashton Kutcher, not his *That '70s Show* character, who usually gets the most credit for sparking the so-uncool-it's-hip fad in 2003 (he says he now has 500-600 in storage). But Justin Timberlake says he was into the ironic lids years before: "[My friend] and I were wearing them when we were 17."

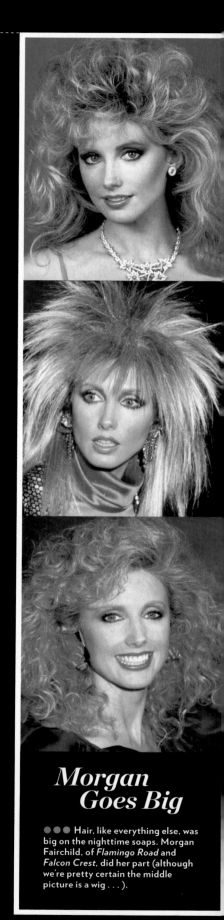

Morgan
Goes Big

●●● Hair, like everything else, was big on the nighttime soaps. Morgan Fairchild, of *Flamingo Road* and *Falcon Crest*, did her part (although we're pretty certain the middle picture is a wig . . .).

Top Tops

LEST WE FORGET: TV'S GREAT HAIRY MOMENTS

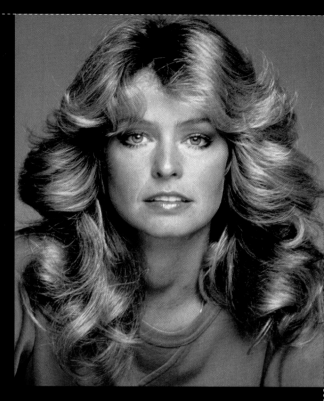

Daring 'do

● ● ● In season 2, the title character in *Felicity*—the drama starring Keri Russell—severed her golden locks. Ratings took a haircut as well. Coincidence? The switch to a Sunday time slot may have played a role as well, but debate simmers.

Remember the Mane

● ● ● Who could forget? Farrah Fawcett's famous cut, introduced to the world on *Charlie's Angels*, sparked global imitation. "Farrah always said that her hair launched two careers—hers and mine," said her stylist José Eber. "Any time you have a hairstyle that makes you feel very womanly and sexy, it will take over the world. And, in this particular case, it did."

Et tu, George?

● ● ● George Clooney—who, in a long career, has rocked a mullet and a Hugh Grant flop—opted for a Caesar cut in the '90s and influenced many, presumably including friends, Romans, countrymen.

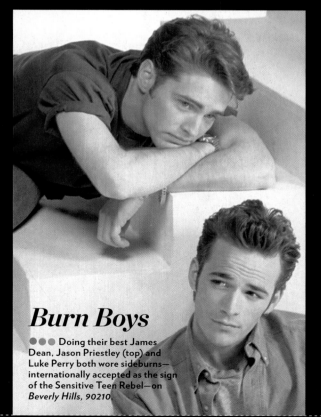

Big 'do

● ● ● The "Rachel"—Jennifer Aniston's 1995 *Friends* hair, imitated around the world—"was a fluke," said stylist Chris McMillan. "She was growing out her bangs, so I just layered her hair around them."

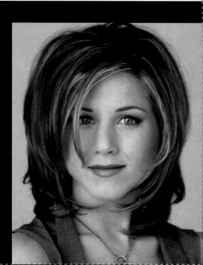

Burn Boys

● ● ● Doing their best James Dean, Jason Priestley (top) and Luke Perry both wore sideburns—internationally accepted as the sign of the Sensitive Teen Rebel—on *Beverly Hills, 90210.*

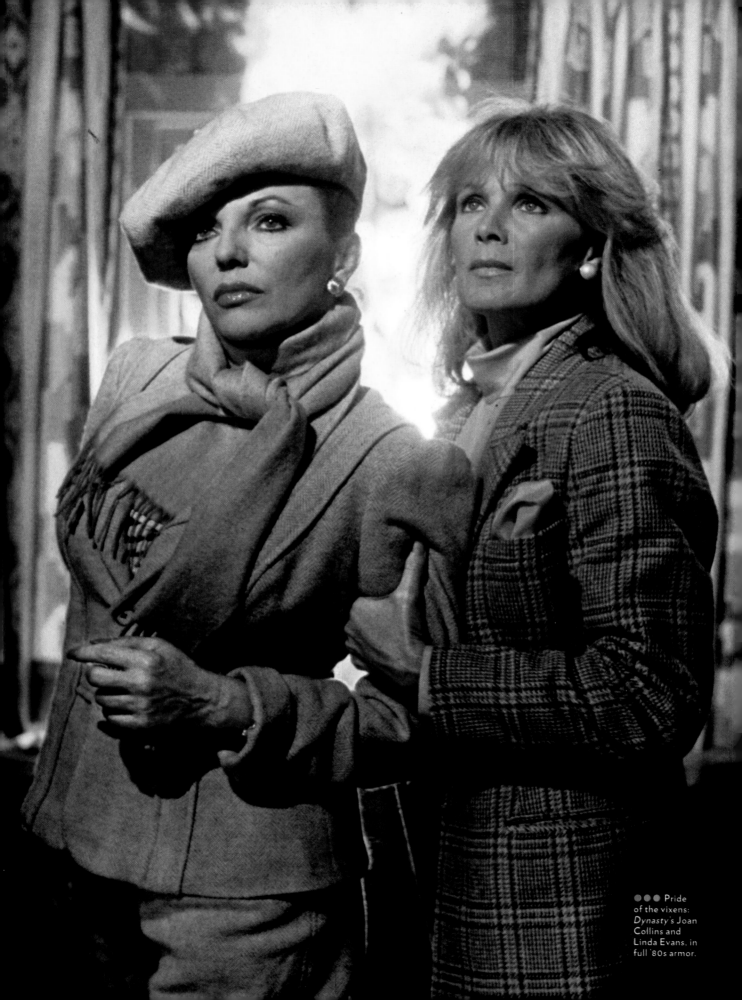

GUILTY PLEASURES

Let's do and say we didn't: With some shows—hello, Aaron Spelling!—the addiction was potent. The desire to proclaim it from the rooftops? Maybe not so much. **Seinfeld** captured the dilemma perfectly when Jerry, casually and repeatedly, told his latest girlfriend, a policewoman, that he didn't watch **Melrose Place**. She hooks him up to a lie detector and discovers that he knows every detail of the *Melrose* plot—down to the fact that Jane has *again* slept with Michael. "That stupid idiot!" screams Jerry. "He left her for Kimberly, he slept with her sister! He tricked her into giving him half her business, and then she goes ahead and sleeps with him again! . . . She's crazy!" But . . . entertaining!!

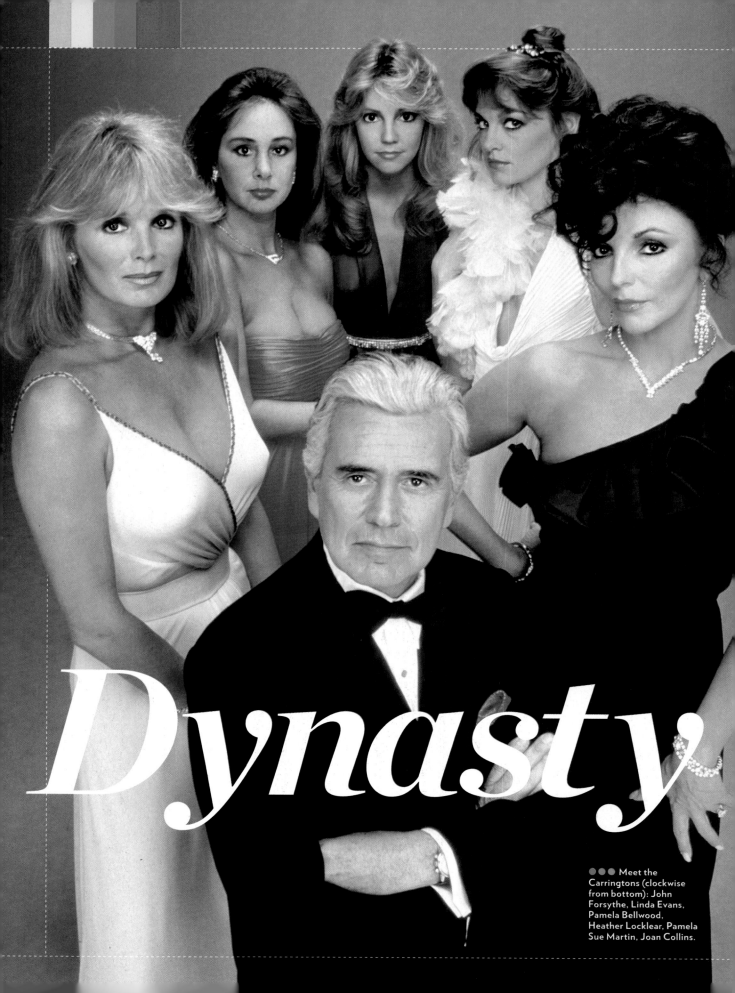

Dynasty

● ● ● Meet the
Carringtons (clockwise
from bottom): John
Forsythe, Linda Evans,
Pamela Bellwood,
Heather Locklear, Pamela
Sue Martin, Joan Collins.

THE TWISTED ANTICS OF A DENVER OIL FAMILY PUT THE NASTY IN *DYNASTY*—AND GLEEFULLY DRAGGED THE PRIME-TIME MELODRAMA INTO THE POND

Louis vs. Schmeling. Ali vs. Frazier. And of course the greatest heavyweight fight of them all—Alexis vs. Krystle in the lily pond on *Dynasty*. Conceived by Aaron Spelling as a clone of the CBS smash *Dallas*, the saga of a Colorado oil baron and his clan of scheming jackals debuted in 1981 to dismal reviews ("None of these characters had a moment of believability," griped one critic after the three-hour pilot; "Dopey, stupid and uninteresting," nutshelled another). But the show's defiant inanity quickly turned it into a hit—a so-bad-it's-good classic that came to define the wretched excess of the '80s.

There was John Forsythe as patriarch Blake Carrington, his immovable silver hair a monument to opulence; Linda Evans as his trophy wife, Krystle, rarely seen without her linebacker shoulder pads; and the tony Joan Collins as Blake's vile ex-wife Alexis, a female J.R. Ewing in gaudy Nolan Miller gowns and hats the size of tires. No plot twist was too ludicrous—

evil twins, comas, kidnappings, plastic surgery to swap out actors (American Pamela Sue Martin was replaced as Blake's daughter by Brit Emma Samms without so much as a wink); even the whole family being shot at by terrorists at a wedding in Moldavia (don't you hate when that happens?). The word "bitch" was bandied about more often than at a Westminster Dog Show, and a spate of shameless girl-on-girl brawls— the infamous, fully coutured Alexis-Krystle pond bath (Krystle won, with two vicious haymakers), a romp in the slop for Samms and spark plug Heather Locklear ("Eat mud!")—became the show's deliciously campy calling card.

An instant weekly parody of itself, *Dynasty* shot to No. 1 in the ratings in 1984 and inspired a line of furs, tuxedos, linens and perfume (Forever Krystle, $150 an ounce: "sweet, warm, vulnerable"). As the garish '80s wound down, though, so too did *Dynasty*, finally running dry in 1989. But it was fun while it lasted. "The day after one of those [catfights] I'd get such a reaction from people," remembered Evans. "They'd say, 'Good for you! Sock her for me! Hit her better next time!' Goodness, they really took it to heart."

POND SCRUM

"You miserable bitch!" With that battle cry on her well-glossed lips, Linda Evans's Krystle launched prime time's most famous catfight. She emerged the winner in her bouts with Alexis (Joan Collins, in the drink, right, and having her neck wrung by Forsythe). Critics credited the two for setting "the gold standard of scratching and clawing." But it was Collins's *über*witch viewers most loved to hate.

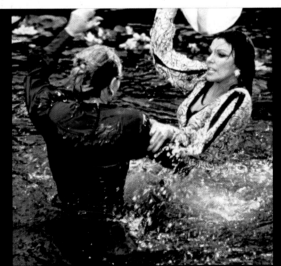

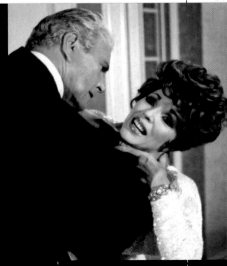

Melrose Place

CONNIVING HOTTIES LIVING IN THE SAME APARTMENT COMPLEX. WHAT COULD GO WRONG?

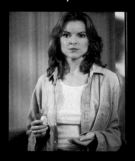
Scaling down the mansions and oil fields of *Dallas* and *Dynasty* to a modest courtyard in L.A., FOX's *Melrose Place* gave the '80s soap opera a '90s makeover: younger stars, hipper clothes, dopier plots. Aaron Spelling, titan of tacky, at first envisioned an earnest drama about the quiet perils of young adulthood (one character, for instance, felt uneasy about working in his dad's furniture store, poor fella). But when ratings floundered midway through the show's first season in 1992, Spelling trooped in *Dynasty* alum Heather Locklear as power-crazed shrew-boss Amanda Woodward, a dose of instant glitz that transformed the show into good, clean camp—and a Nielsen hit embraced by the newly named Generation X.

A fresh-scrubbed cast of cuties didn't hurt—Andrew Shue's moody Billy, Laura Leighton's impish Sydney, Marcia Cross's kooky Kimberly—but it was the show's seven seasons' worth of outlandish scripts that put it over the top. Forget cheese, this was deep-fried Gorgonzola: a stripper extortionist, an empty exhumed coffin and the inevitable drowning of one regular in the courtyard pool (unlucky Brooke, played by future *Sex and the City* star Kristin Davis). And, of course, one of the great reveals in TV history, when Kimberly slid off her wig and unveiled a gruesome, car-crash scar (check it out on YouTube—still cool!). There was even some lurid, behind-the-scenes drama: Pregnant actress Hunter Tylo sued Spelling after she was fired in 1996. "All *Melrose Place* actors and actresses are thin," Spelling's lawyer argued bluntly in court. "They all have flat, tight stomachs" (Tylo was awarded nearly $5 million).

Fairly quickly, the horror-behind-the-wholesomeness formula proved unsustainable, and *Melrose Place* was shuttered in 1999. "We just went over the line, and everyone knew it," producer Charles Pratt Jr. lamented. "It definitely became, 'How much crazier can we get?' [In one scene] Kimberly had an electric drill and was about to give Jack Wagner, who was drooling in a wheelchair, a lobotomy. It left me thinking, 'This is absurd.'" Us too, but that's why we loved it so.

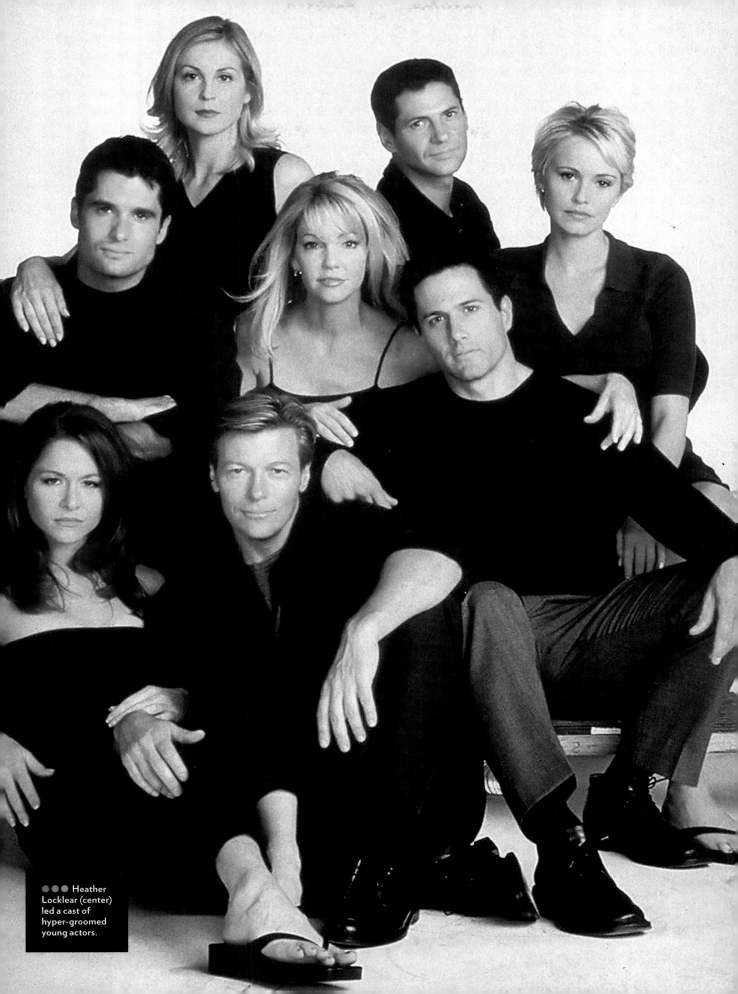

Long before Edward and Jacob squared off in *Twilight*'s Battle of the Beefcakes, two TV dreamboats vied for viewers' hearts and helped launch the modern teen drama. *Beverly Hills, 90210,* a sock-hop soap opera set at a fictional L.A. high school, premiered in 1990 and bestowed a pair of stud muffins on America's teenyboppers—bad boy Dylan (Luke Perry) and twinkle-eyed nice guy Brandon (Jason Priestley). Their dueling sideburns drew hordes of female fans and updated the *Tiger Beat*-era teen idol to the '90s.

And, of course, *90210* offered a weekly moral dilemma: When not slurping shakes at the Peach Pit, the kids faced an over-the-top array of calamities, including date rape, drunk driving, suicide, abortion, AIDS and evil cults. Central to the dramas were a gaggle of indelible female characters: Shannen Doherty as snarky Brenda, Jennie Garth's party girl Kelly, and Tori Spelling's clothes-conscious virgin, Donna (her dad, Aaron Spelling, co-created the show). "We looked at [teen] sexuality in a way you hadn't seen," said the show's other driving force, Darren Star (who went on to create *Sex and the City*). Before winding down in 2000, *90210* spawned a heap of youth-skewing shows like *Melrose Place, Dawson's Creek* and *Party of Five*. None, though, was as fizzy and innocent as the original. "Fun, sex and bonding," Aaron Spelling once said. "That's all a show's got to be."

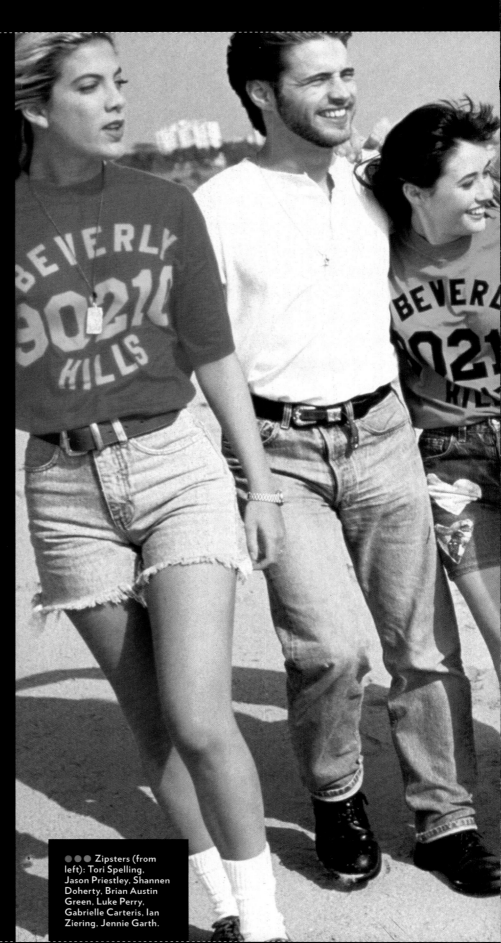

● ● ● Zipsters (from left): Tori Spelling, Jason Priestley, Shannen Doherty, Brian Austin Green, Luke Perry, Gabrielle Carteris, Ian Ziering, Jennie Garth.

Beverly Hills
90210

BY TURNING HIGH SCHOOL INTO A CAULDRON
OF SOCIAL CRISES, IT PAVED THE WAY FOR THE
TEEN SOAPS OF TODAY

Tina Fey ...
as Sarah Palin

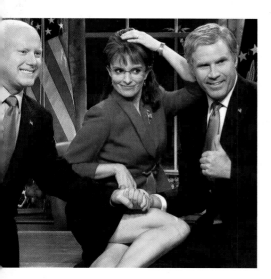

● ● ● *Saturday Night Live* reaped a ratings bonanza when John McCain (portrayed by Darrell Hammond, above left, with Will Ferrell as George Bush) chose Fey's double as his running mate. "People would come up and say, 'What a gift,'" recalls producer Lorne Michaels. Even Palin was a Fey fan. "She thought it was quite funny," an aide said of the *30 Rock* star's first spot-on Palin impression, "particularly because she once dressed up as Tina Fey for Halloween."

Mary Tyler Moore . . . Takes the Pill

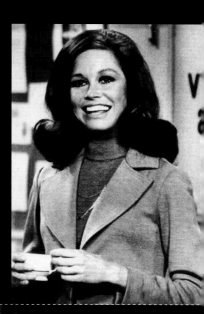

● ● ● NOV. 25, 1972 Mary's mom, exiting a room where Mary and her dad are about to have dinner, calls out, "Don't forget to take your pill!" and the pair simultaneously reply, "I won't!"—making clear that Mary, single career woman, is sexually active.

Tom Cruise . . . Jumps the Couch

○ ○ ● MAY 23, 2005 Fonzie, famously, jumped the shark: Tom Cruise had a similar perception-altering moment when he leapt all over Oprah's couch in a display, he said, of his exuberant love for Katie Holmes. "[It] was a moment," he said later, "and it was real."

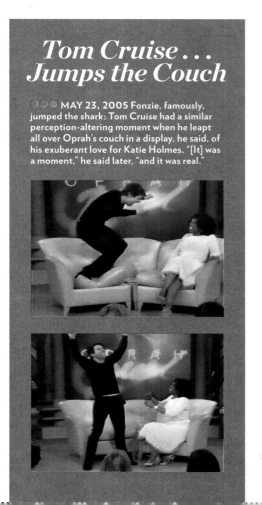

Maude . . . Has an Abortion

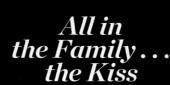

● ● ● NOV. 14 & 21, 1972 The decision by Maude (Bea Arthur, left, with Bill Macy) to have prime time's first legal abortion, two months before the Supreme Court's Roe v. Wade decision, generated thousands of protest letters and calls—and shot the show to No. 5 in the ratings.

All in the Family . . . the Kiss

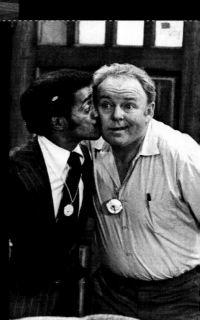

● ● ● FEB. 19, 1972 Pop pioneer Sammy Davis Jr. broke another boundary when he perpetrated the smooch heard round the world—on the cheek of America's favorite bigot, Archie Bunker. The resolution of a complex plot had Sammy planting one on him just as a neighbor takes a snapshot. For a series used to controversy, Lear recalled, "the feedback was wonderful. It was all 'Huzzah!'"

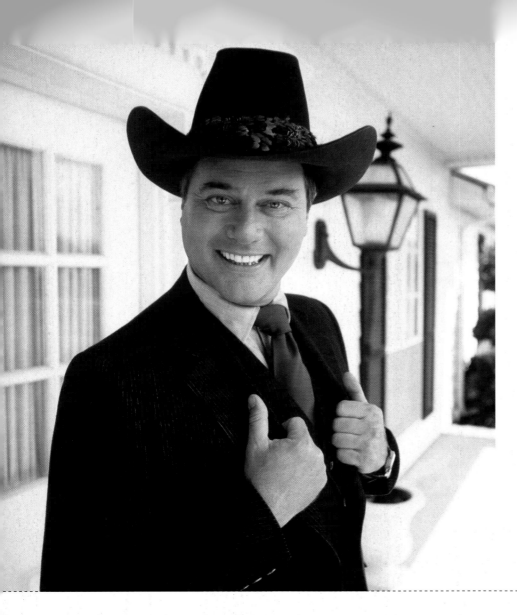

J.R. Ewing ...Gets Plugged

●●● MARCH 21, 1980 When the CBS soap closed out its second season with the fiendish J.R. Ewing (Larry Hagman) taking two slugs from an unseen gunperson, the series stepped up from prime-time hit to worldwide obsession. The show made the covers of TIME and PEOPLE, and "Who Shot J.R.?" was the slogan of choice on T-shirts and bumper stickers. The November resolution— eight months coming, thanks to an actors' strike—drew a record of more than 83 million viewers (surpassed only by *M*A*S*H*'s series finale in 1983). Thanks to decoy endings, even *Dallas*'s stars were surprised by the shooter (Kristin, the ex-mistress, played by Mary Crosby). Make that *most* of the stars. "I figured it out before it aired," said Hagman, who didn't play the omnipotent Ewing for nothing.

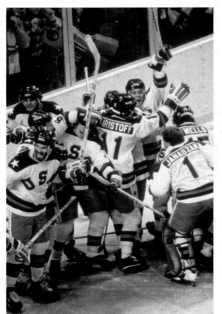

U.S. Hockey ...KO's the U.S.S.R.

●●● FEB. 22, 1980 When the U.S. hockey team beat the Soviets 4-3 in the 1980 Olympics, an entire nation felt it. Sportscaster Al Michaels closed the broadcast with his classic call, "Do you believe in miracles?" You didn't have to be a sports fan to feel the moment, he noted later: "It transcended sports."

Nadia Comaneci ... Scores a 10

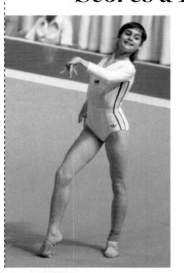

●●● JULY 18, 1976 With an exquisite uneven-parallel-bars routine, Romanian gymnast Nadia Comaneci, 14, earned the first perfect score in Olympic gymnastics history and captivated the world. "As a kid, you don't think it's a big deal," she said years later, all grown up. "But later on, you're like, 'Wow, maybe it was.'"

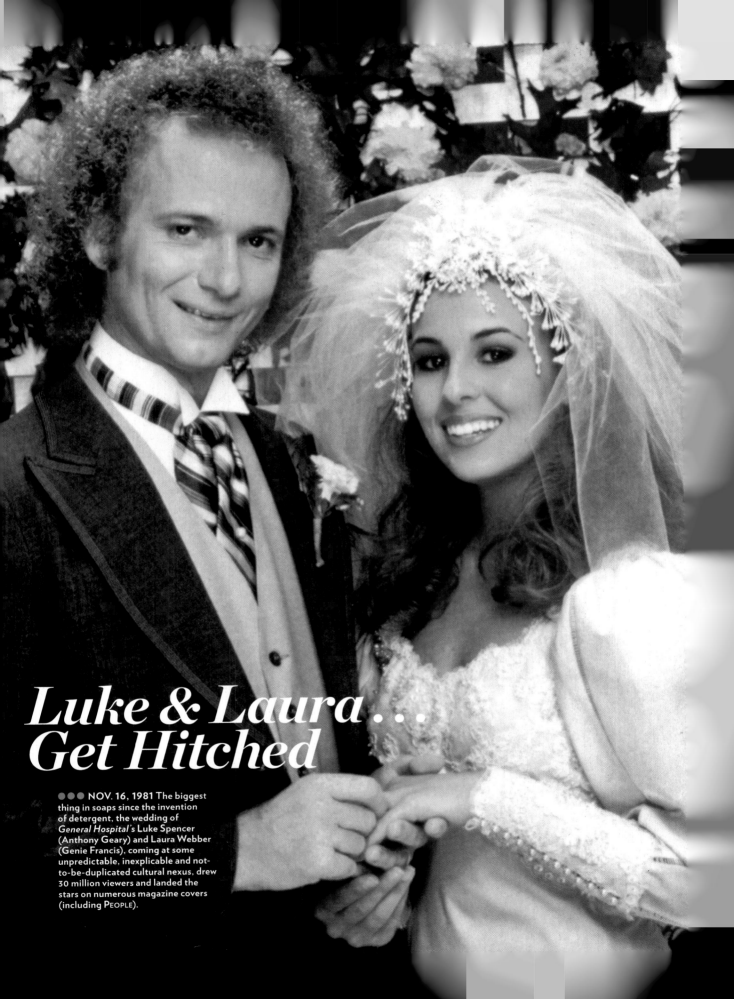

Luke & Laura...
Get Hitched

●●● **NOV. 16, 1981** The biggest
thing in soaps since the invention
of detergent, the wedding of
General Hospital's Luke Spencer
(Anthony Geary) and Laura Webber
(Genie Francis), coming at some
unpredictable, inexplicable and not-
to-be-duplicated cultural nexus, drew
30 million viewers and landed the
stars on numerous magazine covers
(including PEOPLE).

Roots....
America Transfixed

JAN. 23, 1977
Culturally, it was a meteor: powerful, unexpected and landscape-altering. Among the startled: ABC execs, who, worried about the prospects of their series—based on the bestseller in which Alex Haley traced his family's roots back to Africa—decided to run it on eight consecutive nights so it would be over quickly. Instead it became a national obsession, the most-watched miniseries ever, and was nominated for 37 Emmys (winning nine). "America responded so strongly because the scars left by that period had never really been dealt with," said LeVar Burton, who starred as Kunta Kinte, an African captured by slave traders in 1767 and shipped to America. "*Roots* got the nation to take a look at this ugly part of our past."

But the show didn't strike one chord, it struck many. "Why did this work become an instant classic?" asked *Washington Post* columnist William Raspberry. "As Louis Armstrong supposedly said when someone asked him 'What is jazz?', 'If you have to ask, I can't tell you.'"

●●● Bette Midler, Johnny's final guest, sang "One for My Baby (and One More for the Road)".

Johnny Carson's . . . Farewell Show

●●● MAY 22, 1992: "And so it has come to this: I, uh—am one of the lucky people in the world. I found something I always wanted to do, and I have enjoyed every single minute of it. . . . I bid you a very heartfelt good night."

So said John William Carson, then 66, modestly signing off of *The Tonight Show* after 30 years. Typically, the shy, private host left it to others to explain the meaning of it all. No entertainer, said David Letterman, "meant as much to the daily lives of the people of this country for as long as Johnny Carson." Said Johnny's faithful sidekick, Ed McMahon: "You got up, you had breakfast, you went to your job and came home, you had a couple of drinks and dinner and you watched Carson and you went to bed. That was the routine. And if you were lucky, you had wild sex." Said Conan O'Brien: "Anyone who does this for a living is trying in vain to be Johnny Carson."

The Civil War . . . An Epic Surprise

●●● History. Still photographs. Academic experts. Those, traditionally, are not the ingredients of prime-time hits. But Ken Burns's 11-hour, five-years-in-the-making *The Civil War* mesmerized the country, became the highest-rated documentary in PBS history and left critics awed ("Our Iliad," said George F. Will, "has found its Homer"). The director scoured 100,000 photographs before picking 3,000, then used riveting technique—"moving the camera across, moving in, moving through them as if they were from a Hollywood movie," he explained—to bring them to life. But the emotional wallop came from archival quotes. "If I do not return, my dear Sarah," wrote a soldier who was to die at Bull Run, "never forget how much I loved you nor that when my last breath escapes me on the battlefield it will whisper your name."

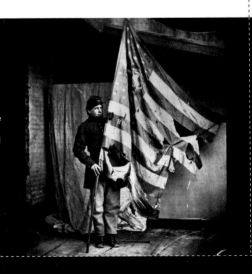

Michael Jackson's . . . *Moonwalk*

●●● **MAY 16, 1983** Jackson unveiled his "moonwalk" during a Motown TV special, leaving rocket scientists scratching their heads. "We spent hours in the editing room discussing every shot," said an amazed producer.

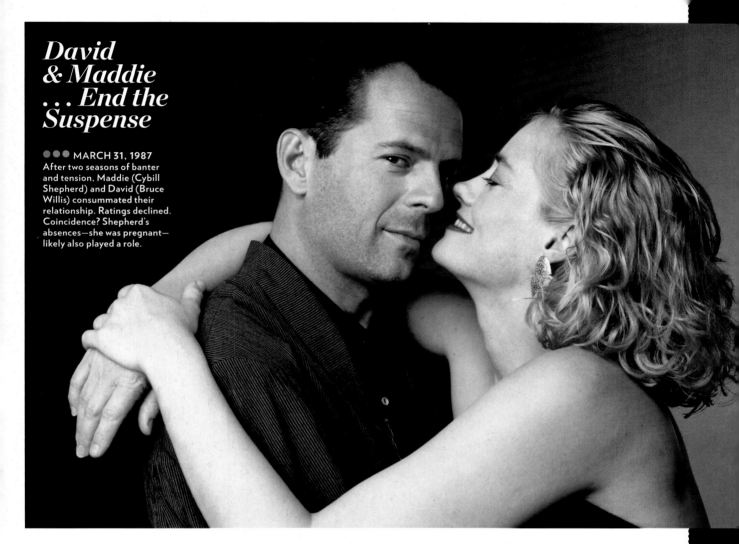

David & Maddie ...End the Suspense

●●● MARCH 31, 1987
After two seasons of banter and tension, Maddie (Cybill Shepherd) and David (Bruce Willis) consummated their relationship. Ratings declined. Coincidence? Shepherd's absences—she was pregnant—likely also played a role.

Ellen ... Comes Out

●●● APRIL 30, 1997 A whopping 36.2 million viewers watched ABC's revolutionary episode, which eschewed preachiness in favor of heartfelt humor (and stars like Laura Dern, above right, and Oprah). Less than two years later the public barely blinked when NBC's gay-themed *Will & Grace* debuted.

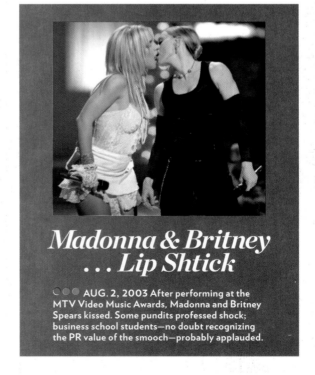

Madonna & Britney ... Lip Shtick

○●● AUG. 2, 2003 After performing at the MTV Video Music Awards, Madonna and Britney Spears kissed. Some pundits professed shock; business school students—no doubt recognizing the PR value of the smooch—probably applauded.

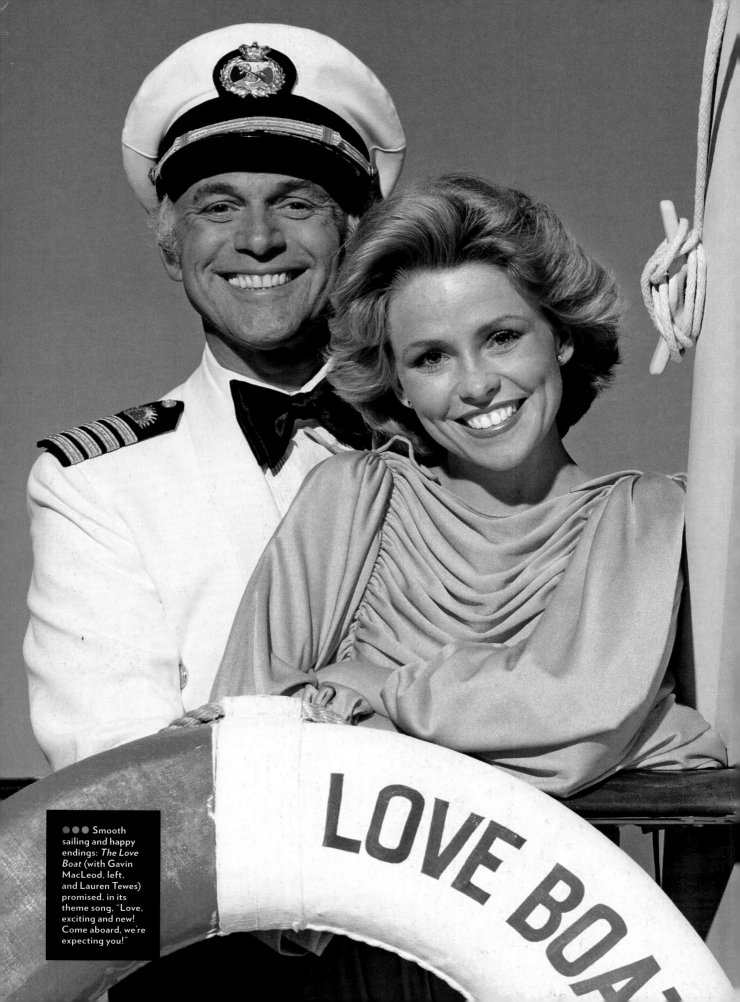

●●● Smooth sailing and happy endings: *The Love Boat* (with Gavin MacLeod, left, and Lauren Tewes) promised, in its theme song, "Love, exciting and new! Come aboard, we're expecting you!"

THAT'S SO...
'70s '80s
'90s '00s

Innocence (**Happy Days**), anxiety (**Lost, 24**), sleekness (**L.A. Law**) and kitsch (**Fantasy Island, The Six Million Dollar Man**): Watch the rerun, feel the vibe of a departed decade

Ze plane! Ze plane! Clouseau rehearsing "The Rain in Spain"? No, that's the 3'11" Mini Montalbán, Tattoo (Hervé Villechaize), announcing the arrival of the next planeload of celebrity guest stars. In a few moments he will stand alongside his boss, the dapper dream-weaver played by Ricardo Montalbán, as he suavely lifts his champagne glass and says, "My dear guests. I am Mr. Roarke, your host. Welcome to Fantasy Island." And so begins another episode of another Aaron Spelling blockbuster, a kind of *Love Boat* in dry dock where wealthy guests ($50,000 a head; no poor pensioners ever alight on the island) are guaranteed to have their dreams come true—and, almost always, learn a Valuable Life Lesson. And viewers are guaranteed to learn what the heck ever happened to the not-quite-A-list likes of *Playboy* model Barbi Benton, character actor Iron Eyes Cody, songwriter Bobby ("Get Your Kicks on Route 66") Troup or '70s teenthrob David Cassidy. As a groom-to-be who makes the mistake of having his bachelor party on the island, Cassidy finds that his fantasy has backfired when he wakes up on his honeymoon in bed with his wife—the stripper who jumped out of his cake. As Tattoo would say, *"Oh, ze pain, ze pain!"*

Fantasy Island

YOU'RE NOT CRAZY— BUT THOSE MEN IN WHITE COATS REALLY HAVE COME TO TAKE YOU AWAY

The Love Boat

Rough seas, stormy weather and E. coli outbreaks may plague real cruise ships, but on this weekly voyage, blue skies and smooth sailing—as well as guest-star turns by blasts from the past (Ginger Rogers, Douglas Fairbanks Jr.), present (John Ritter, Jimmie Walker), future (Tom Hanks) and Planet Cuchi-cuchi (Charo!)—were assured. Despite the groans of cranky critics ("dreadful porridge") and moralists who dubbed the *Pacific Princess* the "lust bucket" for all the wedlock-free hanky-panky that went on in her staterooms, millions of faithful viewers kept the *Boat* afloat for nine years. As Captain Stubing (Gavin MacLeod) and the fresh-faced crew said to passengers at the end of each episode, "Thanks for sailing with us!"

LOVE CHILD

While guests cavorted below decks, MacLeod's Capt. Merrill Stubing was as squeaky-clean as his dress whites. He finally got a chance to emote in 1979 when Jill Whelan came aboard as the bachelor captain's daughter. "She was so precious," said MacLeod. "And that story gave me something that wasn't just fluff."

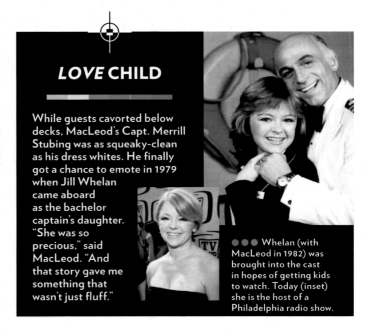

●●● Whelan (with MacLeod in 1982) was brought into the cast in hopes of getting kids to watch. Today (inset) she is the host of a Philadelphia radio show.

Six Million Dollar Man

Test pilot Steve Austin was not only "better stronger, faster" than ordinary mortals, he predated the most famous cyborg of them all, the Terminator, by 11 years (if you count the 1984 movie; 56 if you count back from 2029, the future date from which the killing machine came). Rebuilt with bionic parts after a crash, Austin (Lee Majors) also possessed reproductive powers. A spinoff series, *The Bionic Woman,* shared the Top 20 with *Six* until both were terminated in 1978.

● ● ● Bedtime for Bob: Newhart and Suzanne Pleshette confer.

The Bob Newhart Show

It was enough to send a shrink to therapy. Droll, low-key comedian Bob Newhart feared his show about a droll, low-key psychologist would be lost in a CBS Saturday night cavalcade of hits that included *The Mary Tyler Moore Show, All in the Family* and *M*A*S*H*. But *TBNS* proved anything but depressed. A hit for six seasons (1972-78), it even came back to life 12 years later when Newhart's eponymous follow-up ended with him back in character as Dr. Robert Hartley and in bed with his *TBNS* wife—*Newhart*'s eight seasons had all been a dream.

As befits a series about an idyllic childhood and wholesome family life, *Happy Days* creator Garry Marshall set the show in the town he grew up in: The Bronx. "It didn't work," Marshall recalled. "They used to say in those days, 'Get the people you fly over.'" So he switched the setting from New York to Milwaukee—but he peopled it with characters based on friends and neighbors back in the Big City. "White-bread" Richie Cunningham was based on an aspiring writer he knew in childhood—himself. Arthur Fonzarelli was a composite of hoods from the 'hood. "One had a motorcycle, and he rode us on it," remembered Marshall. "But it's a character that has lasted because everybody in the world is a Richie or a Potsie, but they wanted to be Fonzie."

Alas, Marshall's 1971 pilot, starring Ron Howard, didn't fly, and ABC, which aired it as a segment of *Love, American Style,* showed no further interest until George Lucas's coming-of-age fantasy *American Graffiti* hit in 1973. Starring Howard as a clean-cut, college-bound teen who hero-worshiped a '50s-era hood with a heart of gold, *Graffiti*, along with the success of the 1972 Broadway hit *Grease*, primed audiences for nostalgia. ABC had second thoughts, and *Happy Days* became the sitcom that made Milwaukee a little more famous.

FOREVER POTSIE

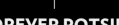

It could have been worse. Born Anson William Heimlich (his cousin authored the "maneuver") he could have been the punch line of countless bad chokes. Yet even after finding fame as dorky Potsie Weber, Anson Williams managed to be taken seriously. A TV director, the dad of six is a hit at home, thanks to helming episodes of *Sabrina, Charmed, Lizzie McGuire* and the teen drama *The Secret Life of the American Teenager.*

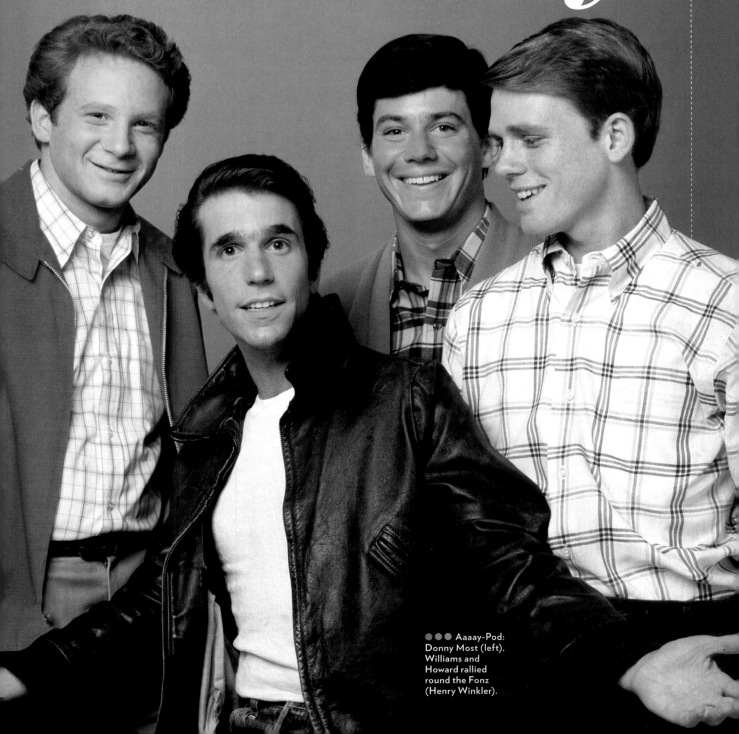

Happy Days

RICHIE, THE FONZ, RALPH MALPH
AND, OF COURSE, POTSIE, CHARMED
PRIME TIME FOR 11 SEASONS

●●● Aaaay-Pod:
Donny Most (left),
Williams and
Howard rallied
round the Fonz
(Henry Winkler).

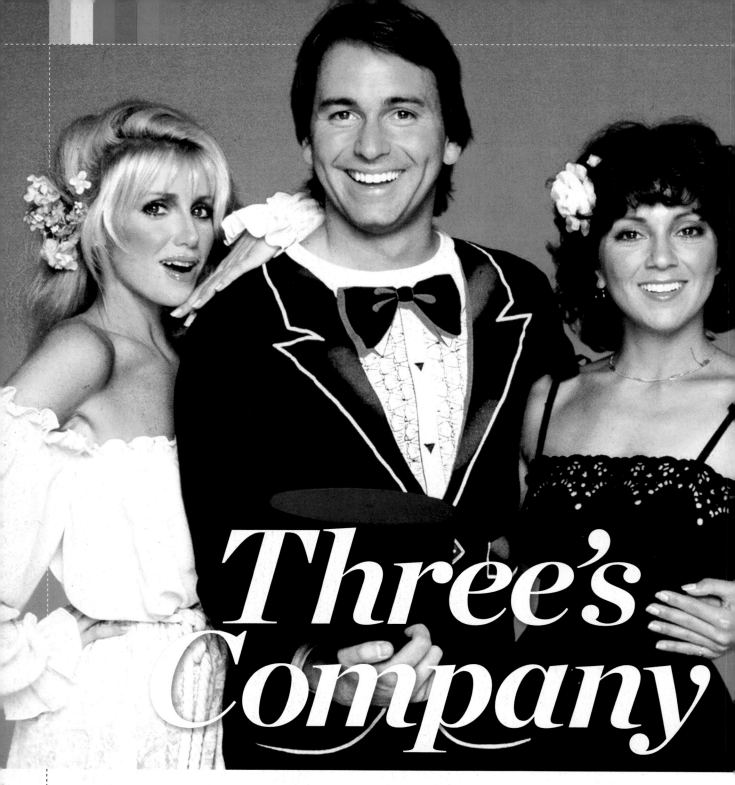

Three's Company

Never in the annals of sex on pre-cable TV was so much titillation generated for the enjoyment of so many by so few. For all the innuendos, giggling and jiggling generated by one of T&A TV's longest-running and highest-rated comedies, the trio of roommates played by Suzanne Somers (above, left), John Ritter and Joyce DeWitt were as chaste as, for their prudish landlord's sake, they pretended to be. With a setup considered racy in its day—two single women sharing their apartment with a single guy!—the show's twist now seems ludicrous if not offensive: Ritter's Jack Tripper pretends to be gay but lusts after every woman in sight, including Somers's

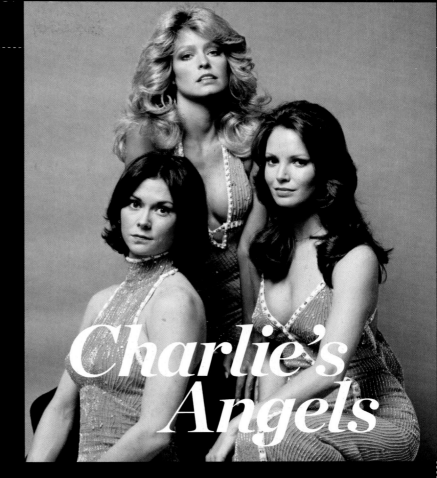

Charlie's Angels

On Sept. 22, 1976, Farrah Fawcett, 29, was just another willowy actress wannabe. The next morning, following the premiere of *Charlie's Angels*, she was a pop-cultural sensation: Her hairdo became a national obsession, her poster sold 12 million copies, and fans around the world scooped up Farrah shampoo, dolls and lunch boxes by the truckload. Big brains strained to explain the Farrah/*Angels* phenomenon, with a TIME critic calling the show—about three beautiful detectives—an "aesthetically ridiculous, commercially brilliant brainstorm surfing blithely atop the zeitgeist's seventh wave." Farrah's manager offered a simpler explanation for success: "Nipples." Stunning Hollywood, Farrah hung up her halo after only one season. Five years and three substitute seraphim later, *Charlie's Angels* gave up the ghost.

beautiful dimbo Chrissy Snow, who cavorts around the share in tight tops and towels. With help from costars Norman Fell and, later, Don Knotts, and the leads' appealing humor and better looks, *Three* stands in good company with the slapstick sitcoms of old.

'ANGELS IN CHAINS'

In a classic *Angels* episode, Jaclyn Smith (left), Farrah Fawcett and Kate Jackson went undercover at a women's prison where the convicts included Kim Basinger. "The show got a 56 share," recalled coproducer Leonard Goldberg. "The rerun got a 52 share. I told [partner] Aaron [Spelling] we should just run it every week until it dropped below 40 and then make another show."

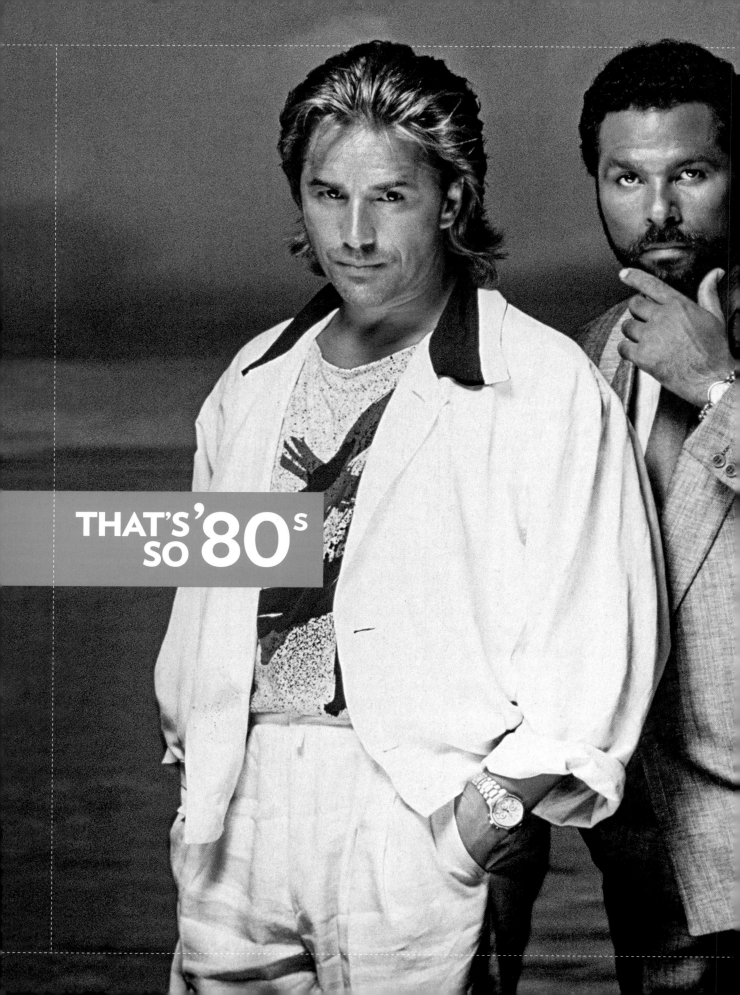

THAT'S
SO '80s

LOUD COLORS, BLARING SOUNDTRACKS AND FANCY LABELS GIVE JUST-THE-FACTS-MA'AM TV COPS AN MTV-READY MAKEOVER

Men Without Socks: With duds by Gianni Versace and Hugo Boss and accessories by Smith & Wesson, designer undercover cops Sonny Crockett and Ricardo Tubbs arrived in 1984 in an explosion of gunfire, synths and bright pastel colors. Hunks of eye candy played by Don Johnson and Philip Michael Thomas, the two MTV lawmen (so called because *Vice* copped the skin-deep flash and self-conscious fury of music videos) had the cushiest gig in crime fiction. Sporting the latest Milan menswear and tooling around Miami in a hormone-fueled Ferrari Testarossa, *Vice*'s flatfoot fashionistos vanquished drug lords and the production values of more traditional cop shows with equal aplomb. The show's ratings soared, and so did Bloomingdale's sales of Crockett & Tubbs–inspired unconstructed jackets, pastel T-shirts, blousy linen pants and slip-on shoes. How to explain the success of a show that valued style over story and flamingo pink and sky-high blue over the black-and-whites driven on every cop show since Joe Friday's *Dragnet*? Said one *Vice* director: "The show is written for an MTV audience [that] is more interested in images, emotions and energy than plot and character and words." Or, as costar Olivia Brown said, "Who wanted to look like Kojak?"

Miami Vice

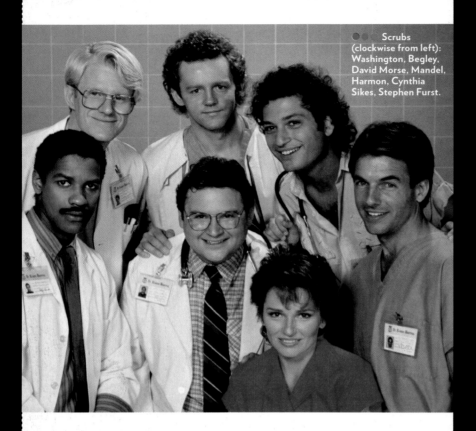

Scrubs (clockwise from left): Washington, Begley, David Morse, Mandel, Harmon, Cynthia Sikes, Stephen Furst.

St. Elsewhere

Doctors Kildare, Casey and Welby of the TVA (Television Medical Association) were quick to condemn the show. From the first episodes, it was clear that the staff of St. Eligius, the run-down teaching hospital where doctors mooned their corporate bosses, surgeons were known to operate in the nude and randy residents bedded one another on slabs in the morgue, violated the standards and practices that had governed TV since the birth of the doctor drama. Earlier medicos were noble hunks who rarely lost a patient; *Elsewhere's* physicians, portrayed by an ensemble cast that included Ed Begley Jr., Howie Mandel, Mark Harmon and Denzel Washington, were shockingly human. The show broke new ground almost every week (story lines about AIDS, abortion, poverty, addiction and prison rape kept NBC censors reaching for the Rolaids), became a crucible for talent (guest stars in recurring roles included Tim Robbins, Alfre Woodard and Christopher Guest; future *Oz* creator Tom Fontana and Bruce Paltrow, dad of Gwyneth, produced) and paved the way for shows like *ER, House* and *Grey's Anatomy*. When fading ratings finally sent *St. Elsewhere* to the TV morgue after six seasons, Begley mourned along with a small but fiercely loyal army of fans. "We've got the toe tag on," he said with regret. "We're in the drawer and it's sealed and locked."

Cybill Shepherd's career was in a post–*Taxi Driver* slide. Bruce Willis's rocket hadn't yet launched. They met in the middle with *Moonlighting*, a genre-bending dramedy (one week there'd be singing, the next a takeoff on Shakespeare) that turned them both, overnight, into TV stars. *Moonlighting* could be wry and too cute for school, and its bloated budgets and bickering stars fueled the gossip press. And the cases pursued by private eyes Maddie Hayes (Shepherd) and David Addison (Willis) seldom made excessive sense. No matter: Fans tuned in for the pair's *double entendre* dialogue and thick-as-smog, will-they-or-won't-they chemistry.

Unfortunately (in retrospect) they did, in a March 1987 episode called "I Am Curious . . . Maddie." With the show's central mystery resolved, its days were numbered. Looking back, should Addison have been less avid? As he once told his partner in the middle of an especially confusing plotline, "Don't blame me. Blame the writers."

MOON STRUCK

Extra quirk was provided by the lovelorn receptionist Allyce Beasley, played by Agnes DiPesto, who recently guest-starred on *As the World Turns* (below, in '87 and '06). Pining for Mr. Right or striving to solve crimes, she tended to whine in rhyme.

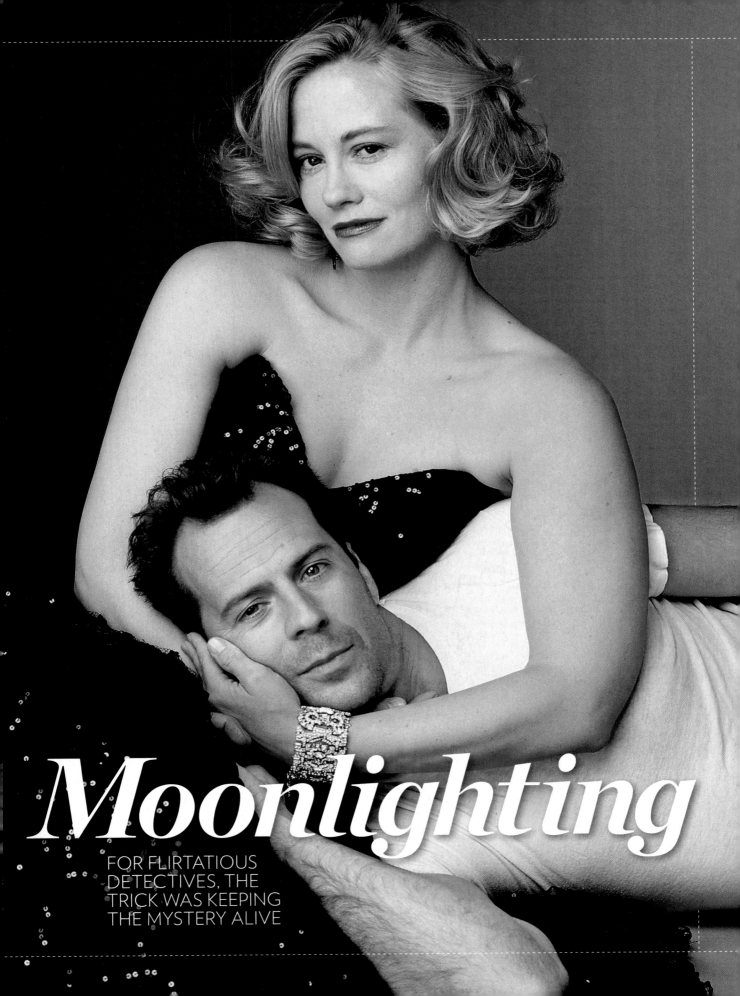

Moonlighting

FOR FLIRTATIOUS
DETECTIVES, THE
TRICK WAS KEEPING
THE MYSTERY ALIVE

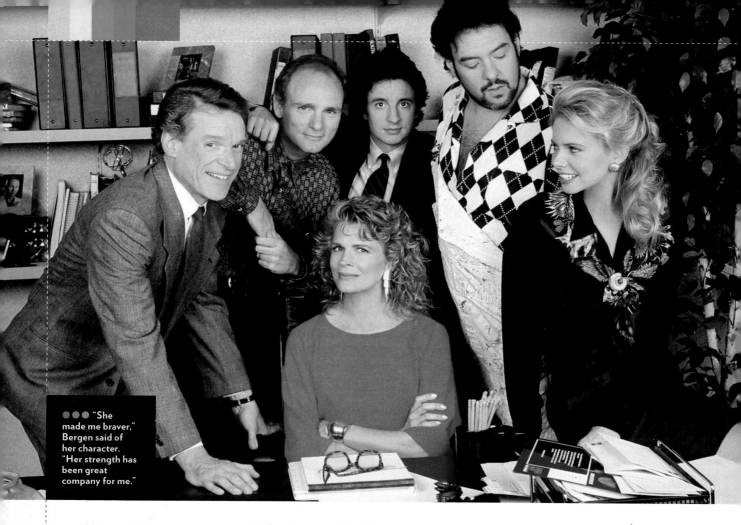

Murphy Brown

A well-groomed veep candidate has on-air dustups with a popular TV personality known for caustic wit and liberal leanings. It's the *Sarah & Dave Show*, right? Nope: Four election cycles before Palin vs. Letterman, GOP Vice President and "family values" advocate Dan Quayle attacked Candice Bergen's CBS hitcom character Murphy Brown for having a fictional baby out of wedlock. The round went to Bergen, whose show was among the highest rated (No. 3) while Quayle's was canceled— he and running mate George Bush lost to Clinton-Gore that fall.

Bergen was then four Emmy-winning seasons into her 10-year run as the arch, fresh-from–Betty Ford anchor of *FYI*, a *60 Minutes*–like magazine show that became a regular cameo stop for real-life anchors and politicians, Walter Cronkite, Katie Couric, Wolf Blitzer, Geraldine Ferraro and Newt Gingrich among them. Commitment-phobic about office assistants (as well as romantic partners), Murphy hired and fired 93 secretaries over the years (Bette Midler, Paul Reubens a.k.a. Pee-wee Herman, Rosie O'Donnell and JFK Jr. all took turns in the hot seat). With support from a crack ensemble (ringing Bergen from left, above, are Charles Kimbrough, Joe Regalbuto, Grant Shaud, Robert Pastorelli and Faith Ford), Murphy, her off-key outbursts of Aretha Franklin's songs not withstanding, took cues from James Brown. "She was able to function in a man's world," said series creator Diane English, "giving as good as she got."

BABY SWIPES

In lieu of cigars, the birth of little Avery Brown was greeted with barbs when VP Dan Quayle accused his single mom of "mocking the importance of fathers." To which Bergen responded in character: "What really defines a family," Murphy said on air, "is commitment, caring and love."

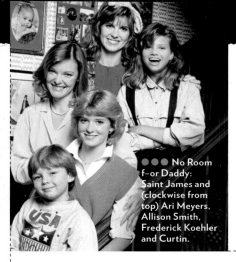

●●● No Room f–or Daddy: Saint James and (clockwise from top) Ari Meyers, Allison Smith, Frederick Koehler and Curtin.

Kate & Allie

With no high-profile male regulars—a novelty at the time—CBS's *Odd Couple*–like effort about two divorced moms who set up house seemed a risky bet. But largely female audiences, it turned out, needed men like a fish needs an iPad: Viewers were happy to watch career woman Susan Saint James and Everywoman Jane Curtin navigate '80s issues, with occasional visits from Y chromosomes to further the plot or fix the plumbing.

L.A. Law

In the first episode, a partner dies at his desk. As he's wheeled out, smarmy divorce lawyer Arnie Becker chirps, "Dibs on his office!"

Clearly, this was not your mother's law drama. "We were the mirror of that Reagan-Bush, 1980s era of greed and lust," said Corbin Bernsen, who played Becker. As happened in cop shows (*Hill Street Blues*) and medical shows (*St. Elsewhere*), *Law* reinvented a genre by focusing on the lives of the characters. The show won 15 Emmys while melding drama and humor (Question: *Is* it okay to laugh when an evil character steps into an open elevator shaft?) while never revealing its greatest secret: the Venus Butterfly technique.

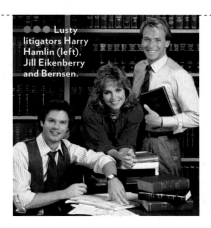

●●● Lusty litigators Harry Hamlin (left), Jill Eikenberry and Bernsen.

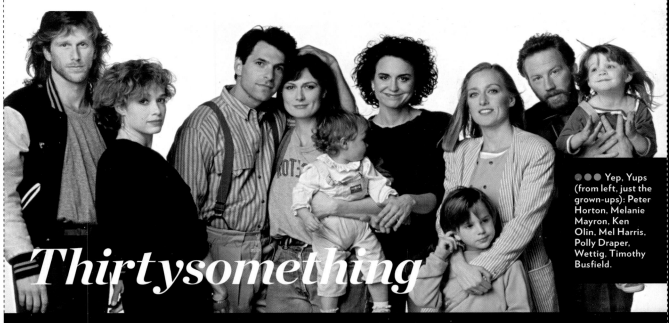

●●● Yep, Yups (from left, just the grown-ups): Peter Horton, Melanie Mayron, Ken Olin, Mel Harris, Polly Draper, Wettig, Timothy Busfield.

Thirtysomething

It was The Big Chill **without** the pot, a surprisingly downbeat-for-TV gathering of boomers who aired their angst and shared their fears of mortality, infidelity and natural-fabric shortages. The show's eight young Philadelphia professionals, their creator said, "know enough about life to be totally confused about it." Others, like David Letterman, who described the gang as "skinny white people from hell," found them simply annoying. Even star Patricia Wettig admitted that the short-lived (four seasons) but influential (its spawn includes generational navel-gazers like *Dawson's Creek*) show could be cloying. "We eat, we talk, we make love and we talk about eating and making love," she said. "And we talk."

Spin City

BOYISH CHARM INTACT, A FORMER SITCOM TEEN ENJOYS A TV RARITY: A SECOND SERIES HIT AS A GROWN-UP

Fixed as he was in the minds of fans as straitlaced Harvard Business wannabe Alex Keaton, it was a shock to learn that 35-year-old *Family Ties* alum Michael J. Fox was chain-smoking cigarettes on the eve of his 1996 debut as star and coproducer of a new sitcom. Fox needn't have been nervous about *Spin City,* the comedy that, thanks in large part to the winning ensemble cast he helped assemble, became a hit and extended his run as one of TV's most likable stars for another four seasons. But something other than ratings may have been on Fox's mind: Unknown to all but his family and a few close friends, he had been diagnosed in 1991 with Parkinson's, a debilitating degenerative disease of the nervous system. He kept his illness secret until 1998, when tremors became increasingly severe and difficult to manage. "It's a bear," he said of the disease after announcing that the episode airing May 24, 2000, would be his last. "But if I start whining, please, somebody, hit me with a hammer. My life has been front-loaded with blessings."

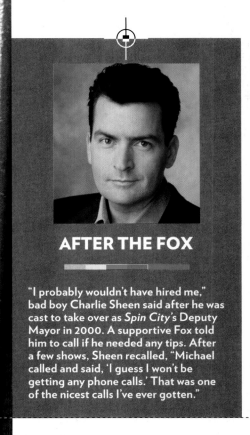

AFTER THE FOX

"I probably wouldn't have hired me," bad boy Charlie Sheen said after he was cast to take over as *Spin City*'s Deputy Mayor in 2000. A supportive Fox told him to call if he needed any tips. After a few shows, Sheen recalled, "Michael called and said, 'I guess I won't be getting any phone calls.' That was one of the nicest calls I've ever gotten."

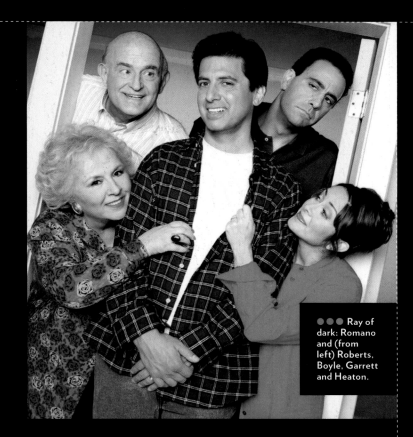

● ● ● Ray of dark: Romano and (from left) Roberts, Boyle, Garrett and Heaton.

Everybody Loves Raymond

New York guy, his wife, cute kids, pushy parents—shake well, and you've got a million sitcoms. But stand-up comic Ray Romano tweaked the recipe by adding a bucket of vitriol. As put-upon sportswriter Ray Barone, Romano raised whining to high comic art, wearily dodging his pesky stay-at-home wife (Patricia Heaton), his meddling cop brother Robert (Brad Garrett) and his endlessly squabbling parents (vets Peter Boyle and Doris Roberts), who treated him like he was 12. The bickering and resentments were hardly new (see *All in the Family*). But what set *Raymond* apart was its almost complete focus on its characters' weaknesses: Unlike the huggy Huxtables, say, the only way you knew the Barones truly loved each other was by the effort they put into their insults.

The formula worked—*Raymond* won two Best Comedy Emmys, set a then-record for star salaries (in 2003 Romano hauled in a cool $1.8 million per episode) and eventually aired in more than 170 countries (showrunner Phil Rosenthal joked he wanted to call the Russian version *Everybody Loves Rasputin*). Never groundbreaking but always true to its daring families-are-hell premise, *Raymond* showed there can be heart and beauty in undiluted dysfunction. "One of the best compliments we would get," says Rosenthal, "was, 'You were listening outside our window last night.'"

Dawson's Creek

UP THE *CREEK* WITH
THE WORLD'S
MOST ARTICULATE TEENS

Two of the show's teens grew up to have big lives: In 2006 Katie Holmes (Joey Potter), then 27, became Mrs. Tom Cruise. Michelle Williams (Jen Lindley) met Heath Ledger on the set of *Brokeback Mountain.* They split before his death in 2008; she is raising their daughter Matilda, 4.

Holmes now, and daughter Suri, 4.

Williams and daughter Matilda.

Dawson Leery, Pacey Witter, good girl Joey Potter and world-weary vixen Jen Lindley: They feel like family to a generation that grew up with *Dawson's Creek.* Set in the seaside hamlet of Capeside, Mass., where the kids talked like philosophy majors and the adults kept a low profile, the *Creek* turned teen angst and tortured young love into a thing of ethereal—no, *not* endless—debate. "The show's about romance, and the first time in every aspect in life—the sweaty palms and weak knees," said creator Kevin Williamson. It was also about star-making: *Creek* launched Michelle Williams, later nominated for an Oscar for *Brokeback Mountain,* and Katie Holmes, who won the title Most Famous Wife Alive by marrying Tom Cruise. Joshua Jackson remains a TV draw on the show *Fringe.* And Dawson himself? James Van Der Beek is still a TV regular, but *Dawson* has proven a tough act to follow.

Ally McBeal

Groundbreaking postfeminist television anthem for the New Woman of the '90s? Or a giant leap backward for all womankind? Discuss!

Few TV characters were more delightfully divisive than FOX's man-happy, miniskirted barrister, who, early on, captured the '90s feminist dilemma in a phrase: "I want to change the world—I just want to get married first." Fans found her struggle to meet The One inspiring; detractors saw a self-involved whiner with little juris and less prudence. Famously, megaprolific writer-producer David E. Kelley stuffed the show with quirks: McBeal's firm, Cage, Fish & Associates, had a unisex bathroom; her boss, Richard Fish, had a thing for women with wattles; Ally's thoughts often became visible onscreen (when she wondered how she'd look with larger breasts, her chest ballooned; when she fretted about her biological clock, a tiny, dancing baby appeared). One week she had passionate sex with a stranger in a car wash; later she shared an exploratory kiss with a female coworker (during sweeps, of course). "These scenes happen when [Kelley] needs to get people's attention," a critic wrote at the time. "I think he would rather have their eyeballs the night before than their respect in the morning."

He got both. *Ally McBeal* had solid ratings for its first three years and in 1999 beat *Everybody Loves Raymond, Frasier, Friends* and *Sex and the City* to win the Emmy for Best Comedy.

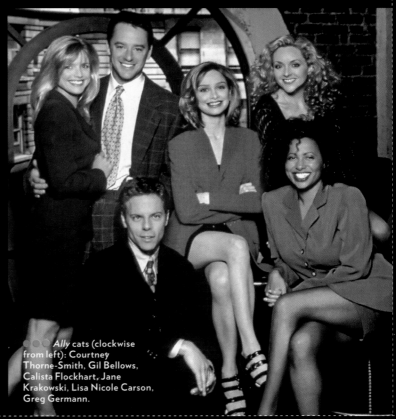

Ally cats (clockwise from left): Courtney Thorne-Smith, Gil Bellows, Calista Flockhart, Jane Krakowski, Lisa Nicole Carson, Greg Germann.

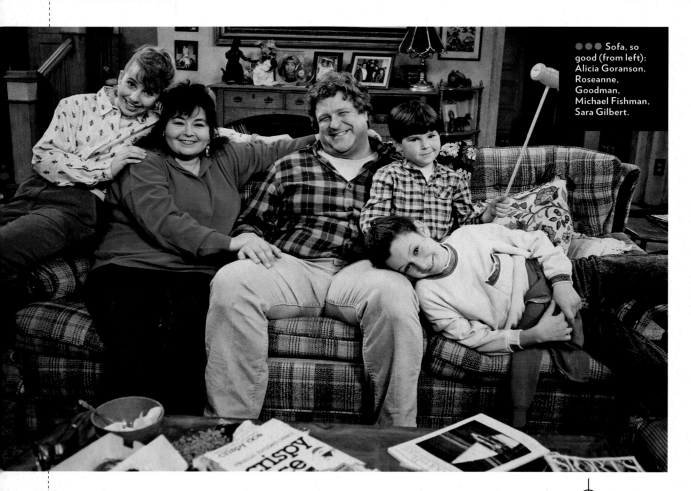

Roseanne

OD'D ON GLAM, VIEWERS FLOCKED TO A WORKING-CLASS ANTIDOTE

There were a lot of ritzy, glitzy nighttime soap operas with a lot of rich, good-looking people," said John Goodman of the revolutionary sitcom on which he costarred, "and here we are, smackin' 'em in the face with a wet fish." Indeed, *Roseanne* was the anti-*Dallas*: a comedy about a working-poor family struggling to make the next mortgage payment. Nourished by the real-life experiences of comic Roseanne—who had shared a 600-sq.-ft. house with her then-husband and three kids before making it big—the show thrived on dark humor and bracing dialogue (Becky: "How long do you think it would take to cook mom's head?" Darlene: "Two and a half hours at 350. I've thought about it a lot."). A Top 10 show for years, *Roseanne* faded after the TV family won a $108 million lottery, and fans fled. Still, said a critic, the show "pushed us into a different stratosphere for sitcom mothers."

A NEW BARR

After shedding 80 lbs. following gastric bypass surgery and having much work done (nose job, breast reduction, tummy tuck, face-lift), Barr told PEOPLE she felt "sexy." But she later regretted taking surgical measures, telling the U.K.'s *Independent*, "No one looks better after cosmetic surgery. Just pink and shiny."

ER

GET ME 100 CCs OF PLASMA, STAT! (AND, SAY, DO YOU HAVE DINNER PLANS?)

Without dinosaurs, there might never have been an *ER*. Translation: Steven Spielberg was about to make a movie based on a medical script by Michael Crichton—until the director discovered the screenwriter was also working on a project about prehistoric reptiles. Spielberg elected to do *Jurassic Park* instead and suggested that maybe the medical idea was better suited to a TV series.

Fifteen seasons and a record 124 Emmy nominations suggest Spielberg was right. The key was splicing hospital drama, rapid-fire jargon and the personal problems of a pretty-much-universally-hot cast. Stars came and, often dramatically, went (George Clooney jumped to movies season 5; Anthony Edwards died of brain cancer while listening to a beautiful version of "Over the Rainbow"). "It goes from 100 miles per hour almost to a dead stop and then starts back up again," said an NBC exec. "You never know where you're going, but you just have to be there."

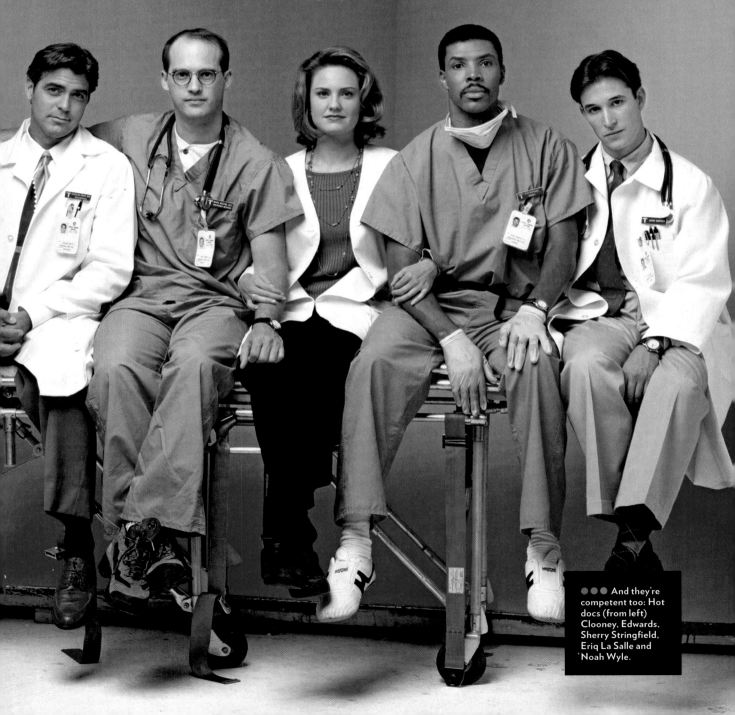

●●● And they're competent too: Hot docs (from left) Clooney, Edwards, Sherry Stringfield, Eriq La Salle and Noah Wyle.

Lost

IT TRANSFORMED TV BY ASKING BIG QUESTIONS. LIKE, IS TIME
IMPERMANENT? AND WHAT'S UP WITH THE FOUR-TOED STATUE?

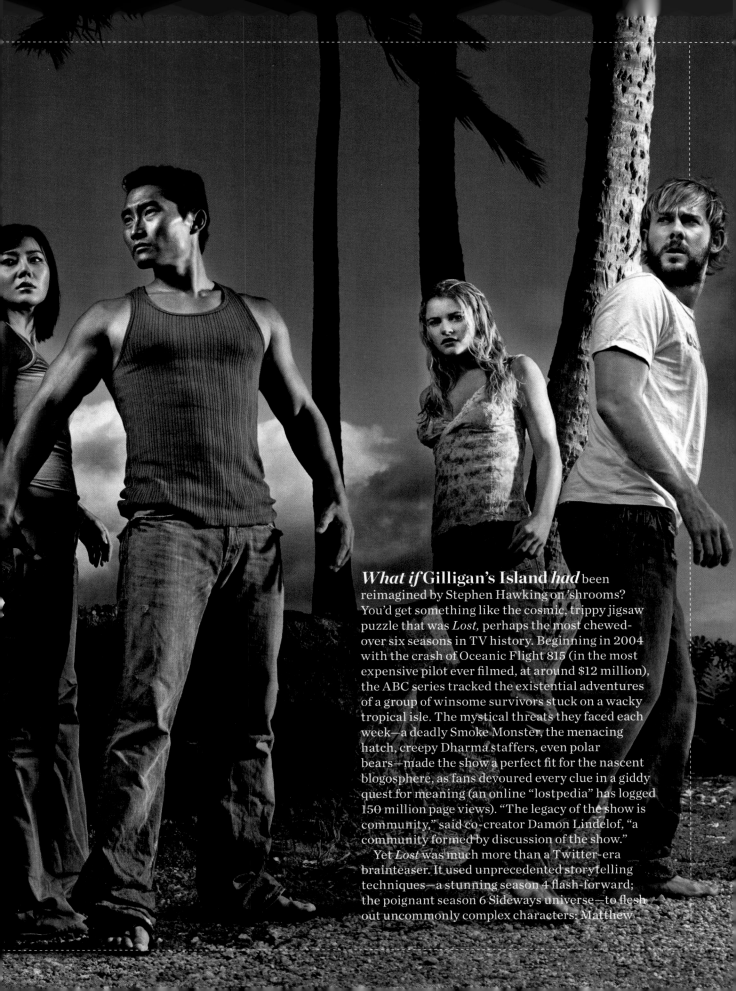

What if Gilligan's Island *had* been reimagined by Stephen Hawking on 'shrooms? You'd get something like the cosmic, trippy jigsaw puzzle that was *Lost,* perhaps the most chewed-over six seasons in TV history. Beginning in 2004 with the crash of Oceanic Flight 815 (in the most expensive pilot ever filmed, at around $12 million), the ABC series tracked the existential adventures of a group of winsome survivors stuck on a wacky tropical isle. The mystical threats they faced each week—a deadly Smoke Monster, the menacing hatch, creepy Dharma staffers, even polar bears—made the show a perfect fit for the nascent blogosphere, as fans devoured every clue in a giddy quest for meaning (an online "lostpedia" has logged 150 million page views). "The legacy of the show is community," said co-creator Damon Lindelof, "a community formed by discussion of the show."

Yet *Lost* was much more than a Twitter-era brainteaser. It used unprecedented storytelling techniques—a stunning season 4 flash-forward; the poignant season 6 Sideways universe—to flesh out uncommonly complex characters: Matthew

Lost...

● ● ● In the pilot episode, Kate (Evangeline Lilly) and Charlie (Dominic Monaghan) reunite after their first run-in with the Smoke Monster.

Fox's conflicted martyr Jack Shephard, Michael Emerson's bug-eyed conniver Ben Linus, and complicated, crippled he-man John Locke, beautifully portrayed by Terry O'Quinn. Its time-bending plot twists turned the island into an Escher stairway, impossible to escape and ruled by its own loopy logic—a nifty narrative trick that birthed a slew of copycat deep-think dramas. Never a huge ratings-grabber, *Lost* fell victim to soap-opera pacing that dampened its mojo after just four seasons, forcing producers into a pioneering gambit—they voluntarily set an end date for the series in 2010, a ticking clock that transformed a cult favorite into a true pop culture phenomenon.

Which brings us to "The End," *Lost*'s much anticipated series finale—at last, some precious answers to the show's big questions: Is the island Hell? Purgatory? A poorly run Sandals resort? But the richly emotional, faith vs. reason finale, like the series itself, left it up to viewers to fit the pieces together, challenging them one last time to find meaning in the mayhem. And that, in the end, is what made *Lost* groundbreaking, deeply rewarding TV—the fun was never in learning the answers but in asking the questions, in pondering life's mysteries, in getting lost.

The Wire

The most realistic show ever made about inner-city America, HBO's *The Wire* was what one critic called "broadcast literature"—a series so dense and complex it made other dramas look like sitcoms. In five seasons on HBO, starting in 2002, it dissected Baltimore's urban underbelly with merciless precision, laying bare a churning mess that was worlds away from standard TV fare (in all, it featured nearly 1,000 characters). Just as it cast no big-name stars, it had neither heroes nor villains—for drug dealers like Marlo Stanfield and Bodie and troubled cops like Jimmy McNulty, morality placed a distant second to survival. And for all its Dickensian depth, *The Wire* aimed at the heart, not the head, making viewers feel poverty, rather than understand it. Created by former Baltimore police reporter David Simon, *The Wire* was too bleak and unrelenting to gain a huge following. But as vivid social commentary—and as a poignant tale of elusive redemption—it had no equal, before or since. When a sociologist talked to real gang leaders about the show, one of them said, simply, "These people get it."

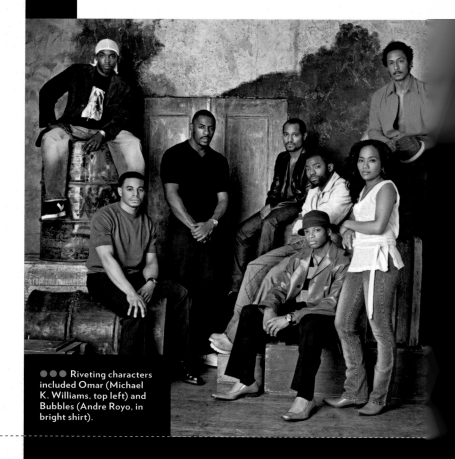

● ● ● Riveting characters included Omar (Michael K. Williams, top left) and Bubbles (Andre Royo, in bright shirt).

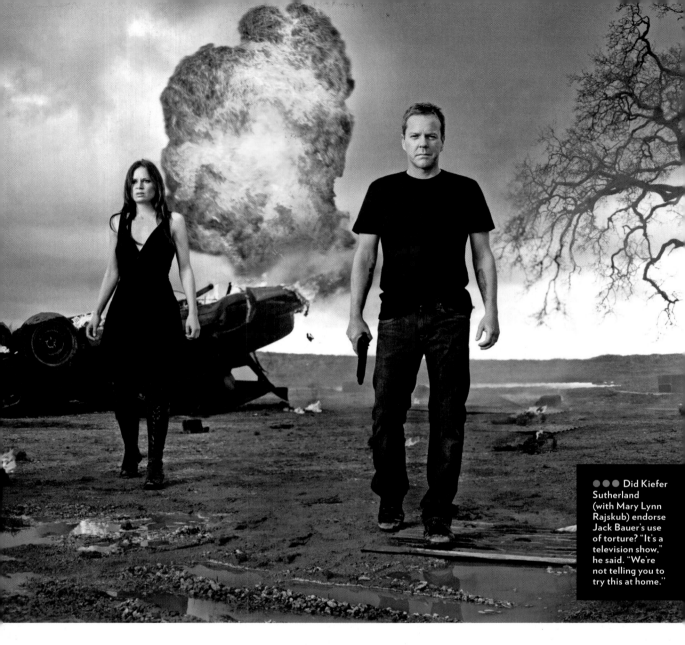

● ● ● Did Kiefer Sutherland (with Mary Lynn Rajskub) endorse Jack Bauer's use of torture? "It's a television show," he said. "We're not telling you to try this at home."

24

FOX'S KINETIC SERIAL CAPTURED A NATION'S DEEP FEARS—AND HAD PEOPLE ASKING, 'WHAT WOULD JACK DO?'

Some TV shows touch a nerve. Real-time thriller *24* strapped a nerve to a chair and beat the stuffing out of it until it talked. In eight explosive seasons on FOX, *24* tapped powerfully into post-9/11 anxieties about terrorism, WMDs and government overreach—dire threats to democracy thwarted weekly by a mirthless Kiefer Sutherland as renegade federal agent Jack Bauer. Innovative (each episode represented an hour in a single day) and spookily prescient (its pilot, which featured a terrorist plane bombing, was filmed five months before 9/11), the series became part of the national debate on torture—the fictional Bauer's reliance on the rough stuff "saved hundreds of thousands of lives," argued Supreme Court Justice Antonin Scalia in a defense of the Bush Administration. "Are you going to convict Jack Bauer?" Yet for all its cultural relevance, *24*'s true strength was its adrenalized format—split screens, ticking clocks and propulsive plotting that reenergized the risky prime-time serial (yielding shows like *Lost*) and created, as one FOX exec put it, the very first "male soap."

30 Rock

CLEVER, ROMANTIC AND DEEPLY ASKEW, IT BROUGHT BRAINS—AND A BALDWIN—BACK TO NETWORK TV

Just when it looked like prime time had turned into one big song and dance, along came a hero to yank the scripted comedy out of the reality wreckage. Tina Fey and her twinkly wit—on display in *30 Rock*—saved the day for smart sitcoms. Debuting in 2006, it dealt with a TV sketch show based on Fey's alma mater *Saturday Night Live* and deftly aimed zingers at taboo subjects—race, politics, even NBC execs. Fey's creation won three Best Comedy Emmys—crucial victories for network TV in an age of cable hits like *The Sopranos*.

How'd Fey do it? Her Sarah Palin impersonation on *SNL* in 2008 helped build buzz. But the show's true genius is meshing styles into a comedy hydra— Fey's own self-deprecating charm as showrunner Liz Lemon (her religion: "I pretty much just do whatever Oprah tells me"), the babbling lunacy of blinged-out man-baby Tracy Morgan ("I'm not on crack," he protested. "I'm straight-up mentally ill!")

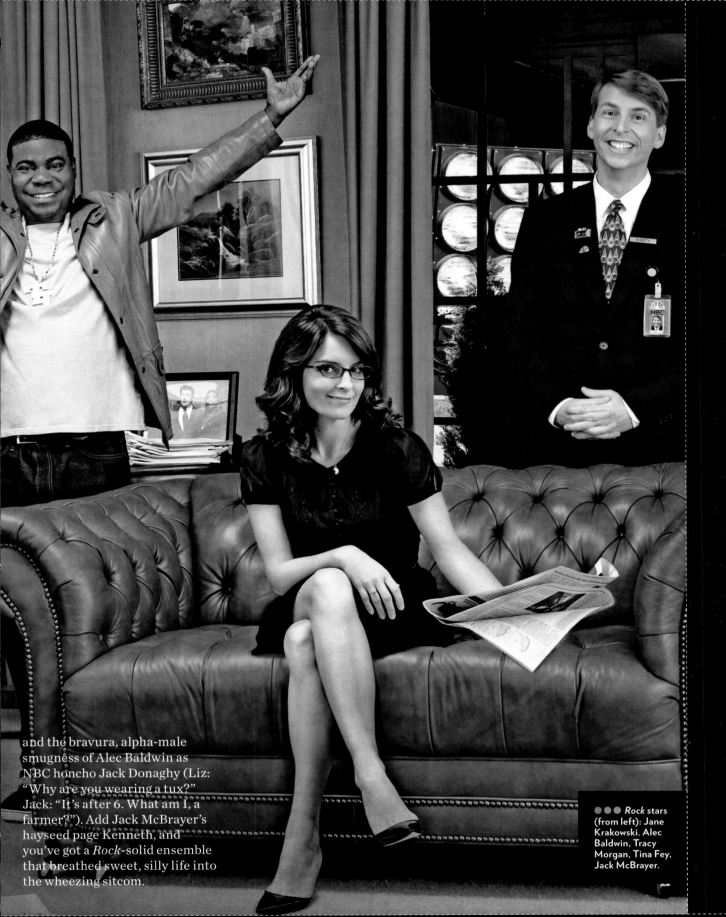

and the bravura, alpha-male smugness of Alec Baldwin as NBC honcho Jack Donaghy (Liz: "Why are you wearing a tux?" Jack: "It's after 6. What am I, a farmer?"). Add Jack McBrayer's hayseed page Kenneth, and you've got a *Rock*-solid ensemble that breathed sweet, silly life into the wheezing sitcom.

● ● ● *Rock* stars (from left): Jane Krakowski, Alec Baldwin, Tracy Morgan, Tina Fey, Jack McBrayer.

The Bachelor

ABC'S *MATCH GAME* ON STEROIDS
SPAWNED A SPINOFF—*THE BACHELORETTE*—
AND BECAME A REALITY-TV STAPLE

It was the flip-flop heard around the world. When Jason Mesnick, *Bachelor*'s first single dad and a huge fan favorite, proposed to Melissa Rycroft on the season 13 finale, he pronounced himself "completely in love." But 17 million viewers' jaws dropped in unison when Mesnick took it all back on the *After the Final Rose* special that aired moments later, dumping Rycroft for runner-up Molly Malaney, 24, a department store buyer from Grand Rapids, Mich. The betrayal set off a tsunami of criticism, and allegations of rose-rigging stung the fickle Seattle bachelor. "I swear on my son's life I would never be part of something like that," Mesnick said. "The reason I changed my mind is that it was in my heart."

Molly, who amazingly gave him a second chance, agreed. "When it comes to love, it's okay to be selfish," she said, "because that's your life, the rest of your life." Last October, Mesnick proposed in Queenstown, New Zealand, site of the traumatic switcheroo. "It was perfect," said Malaney. "Just the two of us—no cameras around." The couple returned to their TV roots for their Feb. 27 wedding in Rancho Palos Verdes, Calif., which ABC filmed for a special shown nine days later. The bride wore Monique Lhuillier and $600,000 worth of Neil Lane diamonds, and even a torrential downpour couldn't dampen their magical moment. As one onlooker noted, "They looked so happy to finally be married."

●●● I like warm weather," says Trista (with Blakesley, Maxwell and Ryan) about moving to Vail. "But I like my husband more!"

Trista Rehn and Ryan Sutter

THE BACHELOR-BACHELORETTE EXPERIMENT HAD ITS GREATEST TRIUMPH EARLY ON

There are fairy-tale endings; this was a fairy-tale beginning. After Trista Rehn chose her groom at the conclusion of the first season of *The Bachelorette*, she and firefighter Ryan Sutter let ABC arrange for the 30,000 roses, 5,000 yards of pink ribbon and $15,000 wedding cake that graced their December 2003 Palm Springs nuptials, seen by more than 17 million viewers. "In the morning I call her Sunshine," gushed the sensitive, poetry-writing Sutter of his self-described "girlie girl" bride, a former physical therapist, before the two jetted off for a 10-day Fijian honeymoon.

Out of this world romantic? Sure, but the union has gone the distance and become the unicorn of reality-TV romance: a love with legs! After settling in Sutter's hometown of Vail, Colo., and years of trying to become parents, Rehn, now 37, and Sutter, now 36, welcomed son Maxwell in 2007 and daughter Blakesley last year. "No. 1, you have to be committed," Trista says. "When we said to each other we wanted to spend the rest of our lives together, we meant it. And No. 2, we have a really good time together." Adds Ryan: "Sense of humor is right at the top. Especially now with kids, you just do dumb things."

Charlie O'Connell and Sarah Brice

Give them an A for effort. By the time real estate investor and sometime actor Charlie O'Connell (look-alike brother of *Crossing Jordan* actor Jerry) arrived as the star of 2005's season 7, *Bachelor* was sinking under a stale formula and regularly scheduled post-show breakups. Before the native New Yorker handed a rose to Sarah Brice, then 24, a petite Texas nurse, O'Connell, 35, proved to be a charmingly roguish, fast-talking, hard-drinking breath of fresh air. ("Hilarious," said the *L.A. Times*.) Later, however, things got rocky. After moving in together, the pair broke up in 2007. ("He lived a very partying type of lifestyle," Brice said. "It wasn't something I was comfortable with.") Though they later reunited, by April 2010 the bloom was off that long-ago rose. "I think it was a mutual breakup," O'Connell explained to PEOPLE. "The thing is, we dated for five years and [were] just arguing over the same things. Eventually you've got to go your separate ways." He's lining up acting jobs. And Brice? "She's a great girl," O'Connell says. "I'm sure she'll do great."

Bob Guiney

In 2003 "Bachelor Bob" kissed a bevy of beauties, then gave Estella Gardinier a diamond "promise" ring before an audience of 18.6 million. But the romance faded fast, and the couple barely spoke after the finale. Nine months later he wed soap opera actress Rebecca Budig; they split last year. Nowadays he appears on VH1's *Undateable* and fronts Band from TV, a celebrity cover band.

Aaron Buerge

He was Bachelor No. 2—the handsome Missouri restaurateur who, at season 2's end, gave a rose and a 2.75-carat engagement ring to Helene Eksterowicz. He broke up with her five weeks later ("It felt like a bomb dropped," she said at the time). Afterward, Eksterowicz, now 35, cowrote a book called *Nobody's Perfect: What to Do When You've Fallen for a Jerk but You Want to Make It Work*; Buerge, now 36, married Angye McIntosh, an insurance agent, in 2009.

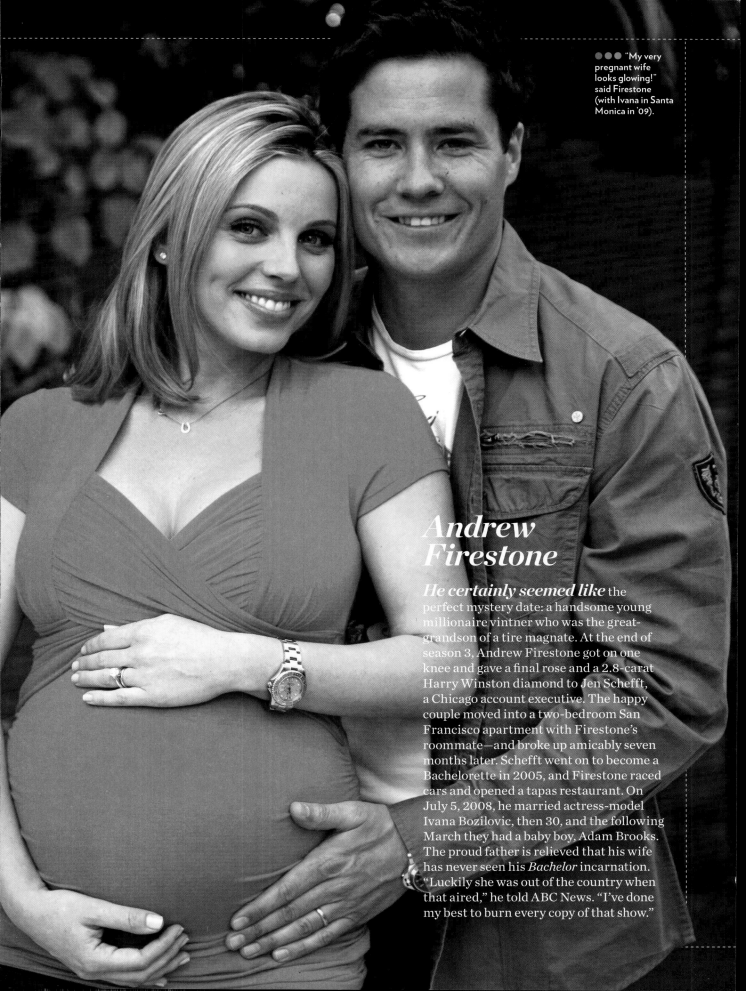

Andrew Firestone

He certainly seemed like the perfect mystery date: a handsome young millionaire vintner who was the great-grandson of a tire magnate. At the end of season 3, Andrew Firestone got on one knee and gave a final rose and a 2.8-carat Harry Winston diamond to Jen Schefft, a Chicago account executive. The happy couple moved into a two-bedroom San Francisco apartment with Firestone's roommate—and broke up amicably seven months later. Schefft went on to become a Bachelorette in 2005, and Firestone raced cars and opened a tapas restaurant. On July 5, 2008, he married actress-model Ivana Bozilovic, then 30, and the following March they had a baby boy, Adam Brooks. The proud father is relieved that his wife has never seen his *Bachelor* incarnation. "Luckily she was out of the country when that aired," he told ABC News. "I've done my best to burn every copy of that show."

Glee

GOTTA SING! GOTTA DANCE! HARMONIC MISFITS
PUT HIGH (SCHOOL) ANXIETY TO MUSIC, AND FOX
HAS AN OUT-OF-THE-BOX HIT

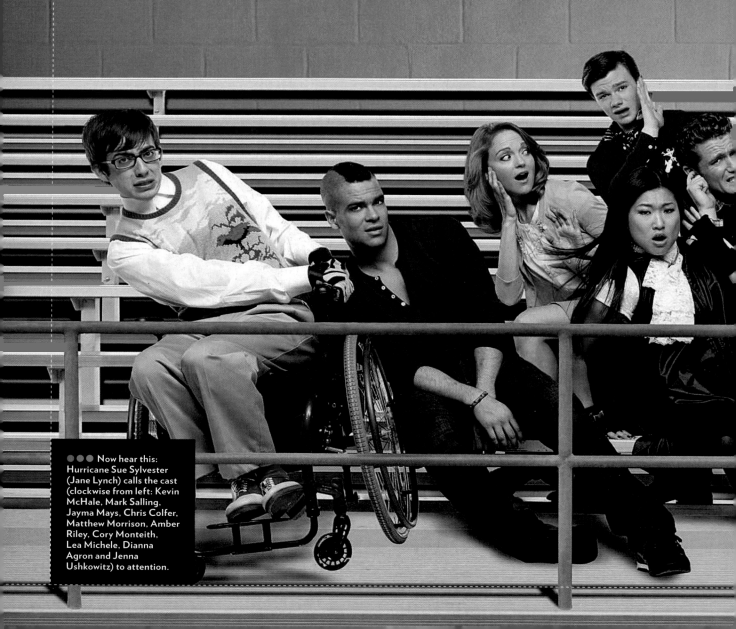

●●● Now hear this:
Hurricane Sue Sylvester
(Jane Lynch) calls the cast
(clockwise from left: Kevin
McHale, Mark Salling,
Jayma Mays, Chris Colfer,
Matthew Morrison, Amber
Riley, Cory Monteith,
Lea Michele, Dianna
Agron and Jenna
Ushkowitz) to attention.

Doing something that had never been done in the history of television—the staging of a weekly, crowd-wowing Broadway-style musical that becomes a hit in prime time—is one thing. Creating a loyal army of unabashed show tune and power ballad loving, gotta-dance theater freaks (a.k.a. *gleeks*) in the process is the kind of showbiz serendipity that no doubt makes creators Ian Brennan, Brad Falchuk and Ryan Murphy want to sing. Why does it work? "There's so much on the air right now about people with guns, or sci-fi, or lawyers running around," Murphy, who selects the music, told *Variety*. "This is a different genre, there's nothing like it on the air at the networks and cable. . . . That's why *Idol* worked. It's pure escapism."

Gleek Nation earnestly debated the single best number in a season full of them as Lima, Ohio's William McKinley High School Glee Club prepared to compete in Regionals . On the short list: Wheelchair-bound Artie (Kevin McHale) led the troupe in a dream scene to Billy Idol's "Dancing with Myself"; Rachel (Lea Michele) belted a Streisand-worthy "Don't Rain on My Parade," and the whole gang united for Journey's "Don't Stop Believin'." But Glee Club nemesis Sue Sylvester (Jane Lynch), who vogued as Madonna in a memorable episode, would no doubt give the prize to . . . Sue Sylvester. As she so succinctly put it in one episode, "I'm a legend. It's happened."

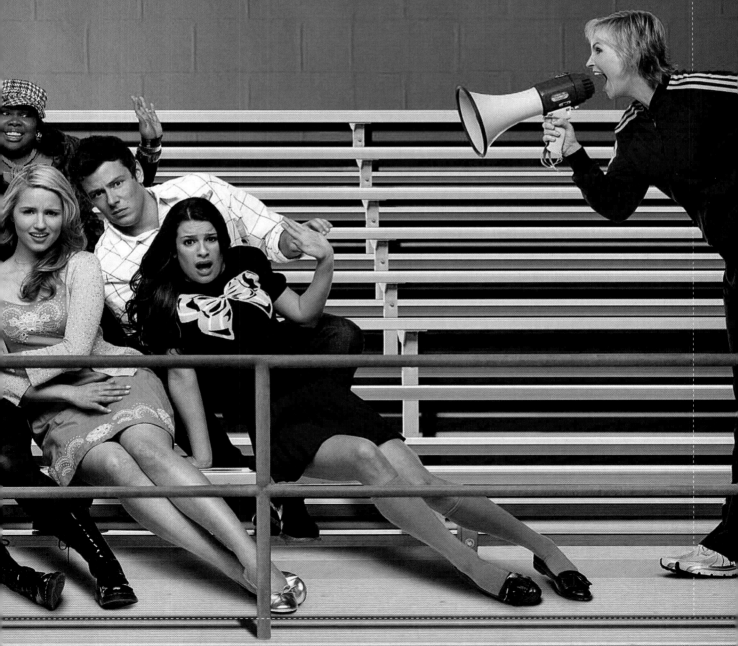

The Brady Bunch

AN INNOCENT SITCOM ABOUT SIX KIDS LASTED FIVE SEASONS BUT STILL ECHOES THROUGH A GENERATION

Nowadays it's part of the lexicon: A modern family. A blended household. A motley crew. Beyond that, *The Brady Bunch* has spawned satires and stage shows. But for most of a five-season run that ended in 1974, *The Brady Bunch* was just a sitcom, not a symbol. The setup: Mike Brady (Robert Reed) and Carol Martin (Florence Henderson) married and moved into their sprawling suburban homestead with her three girls, his three boys and Alice the maid. Small dramas ensued on a weekly basis, feelings, and even noses, got bruised, but everyone seemed to make up before bedtime. Compared to what was going on in the real world, the Bradys offered a kind of balm. As one critic wrote, "Coming at the end of the turbulent 1960s, it portrayed a family life that many people didn't have but secretly longed for."

In the snarky, electron-paced Internet age, it would probably be roadkill. To critics who call the show too naïve, Christopher Knight, who played Peter Brady, says that *Brady*'s "simplicity is perhaps why it succeeded. It was perfect for children, and that's what this was, a show for children."

● ● ● *Brady* bonanza: Henderson (Carol) and Reed (Mike) surrounded by the kids (clockwise, from left): Eve Plumb (Jan); Knight (Peter); Barry Williams (Greg); Ann B. Davis (Alice Nelson); Maureen McCormick (Marcia); Mike Lookinland (Bobby); Susan Olsen (Cindy).

Leave It to Beaver

GOLLY! ONCE, THE BEAV AND WALLY AND JUNE AND WARD WERE TV'S MODERN FAMILY

It blasted off on Oct. 4, 1957, the day Sputnik launched. And it fell back to earth six seasons later, in June 1963, on the eve of two other generational time-markers (the assassination of President John F. Kennedy, the Beatles' first appearance on *Ed Sullivan*). In between it offered a sweet but savvy innocence and time-capsule dialogue that may never be seen and heard again on TV. "Hot dog, Beaver!" exclaimed brother Wally upon discovering that a rustic vacation cabin lacked a familiar nemesis. "There's no bathtub!"

For stars Jerry Mathers (the Beav is now 62) and Tony Dow (Wally, 65), life on-set was as idyllic as their TV world, with access to a Universal back lot fishin' hole and grown-ups as caring and wise as Ward and June, the fictional parents played by the late Hugh Beaumont and Barbara Billingsley, 94. "I remember there was this crewman who said 'Damnit' or something once," Dow recalled. "Never saw him again."

SMARM SCHOOL

Ken Osmond achieved immortality as the character *The New York Times* called "slick, weaselly Eddie Haskell." But surely the adventures of Eddie and the gang were too quaint for today's sophisticated youth? "Nah," said Osmond, a retired L.A. police officer. "Kids are still the same as they were in 1810."

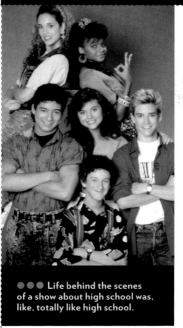

● ● ● **Life behind the scenes** of a show about high school was, like, totally like high school.

Saved by the Bell

The smart money was on Bugs Bunny. "We constantly thought we were going to be canceled," recalled former tween throb Mark-Paul Gosselaar, who played lovable schemer guy Zack Morris in NBC's Saturday morning gamble. But *Saved,* the sole non-cartoon aired in that kids-only time slot by the major networks when it debuted in 1989, became a hit and a generational touchstone for audiences who grew up with the Bayside High in crowd—and for the cast, who were going through the same growing pains as their fans. "All of us dated at one point or another," Gosselaar said. "Sometimes the girls would gang up on the guys. All that stuff you did in high school, like, 'How could you talk to *him*?'"

The Facts of Life

It started as a stilted *Diff'rent Strokes* spinoff but morphed into something larger. A genial, fluff-filled chronicle of four goofy girls at prep school, *The Facts of Life* ran for nine years, longer than *The Cosby Show* or *Family Ties*. The growing-up adventures of Natalie, Jo, Blair and Tootie, mother-henned by Edna Garrett (Charlotte Rae), broke little new ground and offered young viewers much more comfort than challenge—but it's a rare woman between 30 and 40 who can't still hum the theme song.

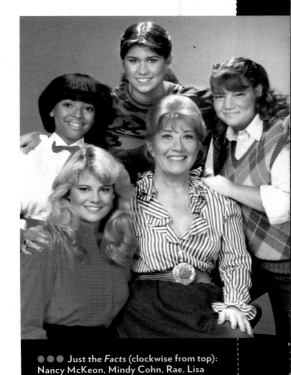

● ● ● **Just the** *Facts* (clockwise from top): Nancy McKeon, Mindy Cohn, Rae, Lisa Whelchel and Kim Fields.